C.E.

CREATIVE EXPANSION

CREATE

VOLUME | 01

R

EXPANSION

JOURNAL V SERIES

Expand mindfully into the greatest and grandest version of yourself that your physical vessel can hold. Daily Mindfulness, Introspective writing, Creative expression and Wisdom reflection. Available now. Welcome to you.

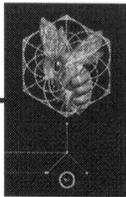

MINDFUL EXPANSION

M.E.

Mindful Expansion is equal parts journal, personal expansion tool, experience tracker, mind awakener, conscientious enhancement ally and intergalactic space ship. All deliberately created and designed to help launch you into the greatest and grandest version of YOU.

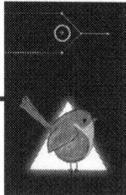

INTROSPECTIVE EXPANSION

I.E.

Introspective Expansion is your safe place to create, imagine, write and invite insightful introspection into your experience.

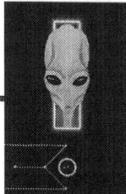

CREATIVE EXPANSION

C.E.

Creative Expansion is your safe place to create, explore, doodle and invite imagination into your experience.

WISDOM EXPANSION

W.E.

coming soon

Wisdom Expansion is equal parts journal, personal expansion tool, experience tracker, accountabilibuddy, conscientious enhancement ally and intergalactic space ship. All deliberately created and designed to help launch you into the greatest and grandest version of YOU.

Connect with the Author and Creator

BRANDON THOMAS

instagram.com/brandonthomas369

Might as well check out his podcast
Expanding Reality

RIDICULOUSLY ORIGINAL AUTHORS

RIDIGINAL
PUBLISHING

instagram.com/ridiginalpublishing

The representations offered by the artists have been rendered in black and white and reformatted with their expressed permission for this publication. Their contact information, as well as clearer, in color and higher quality images and prints are available for further enjoyment.

Heed your calling to investigate and connect further with these remarkable artists and their spectacular portfolios, located in the back of this book.

expand

BOUNDLESS CURIOSITY

IMAGINATIVE EXPANSION

AUTHENTIC CREATION

EXPANSIVE DISCOVERY

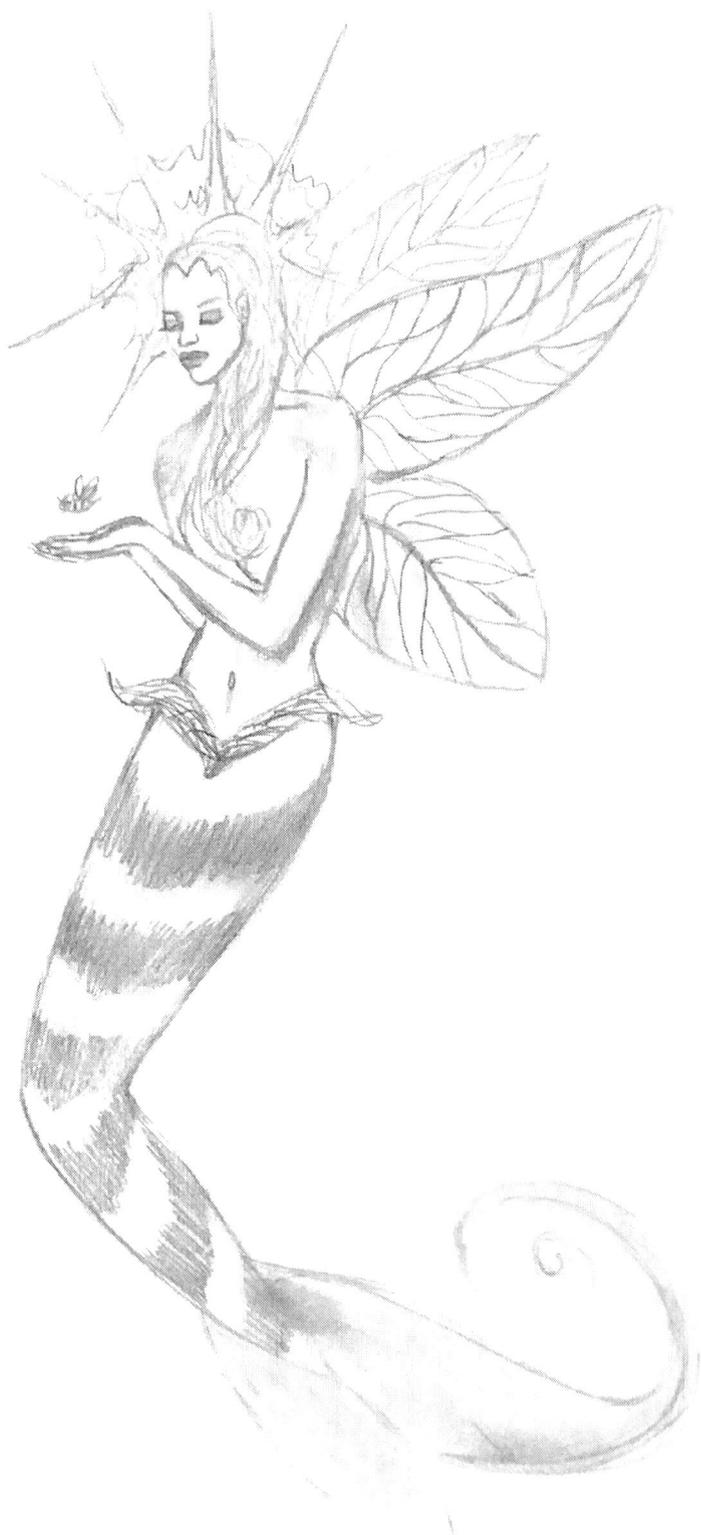

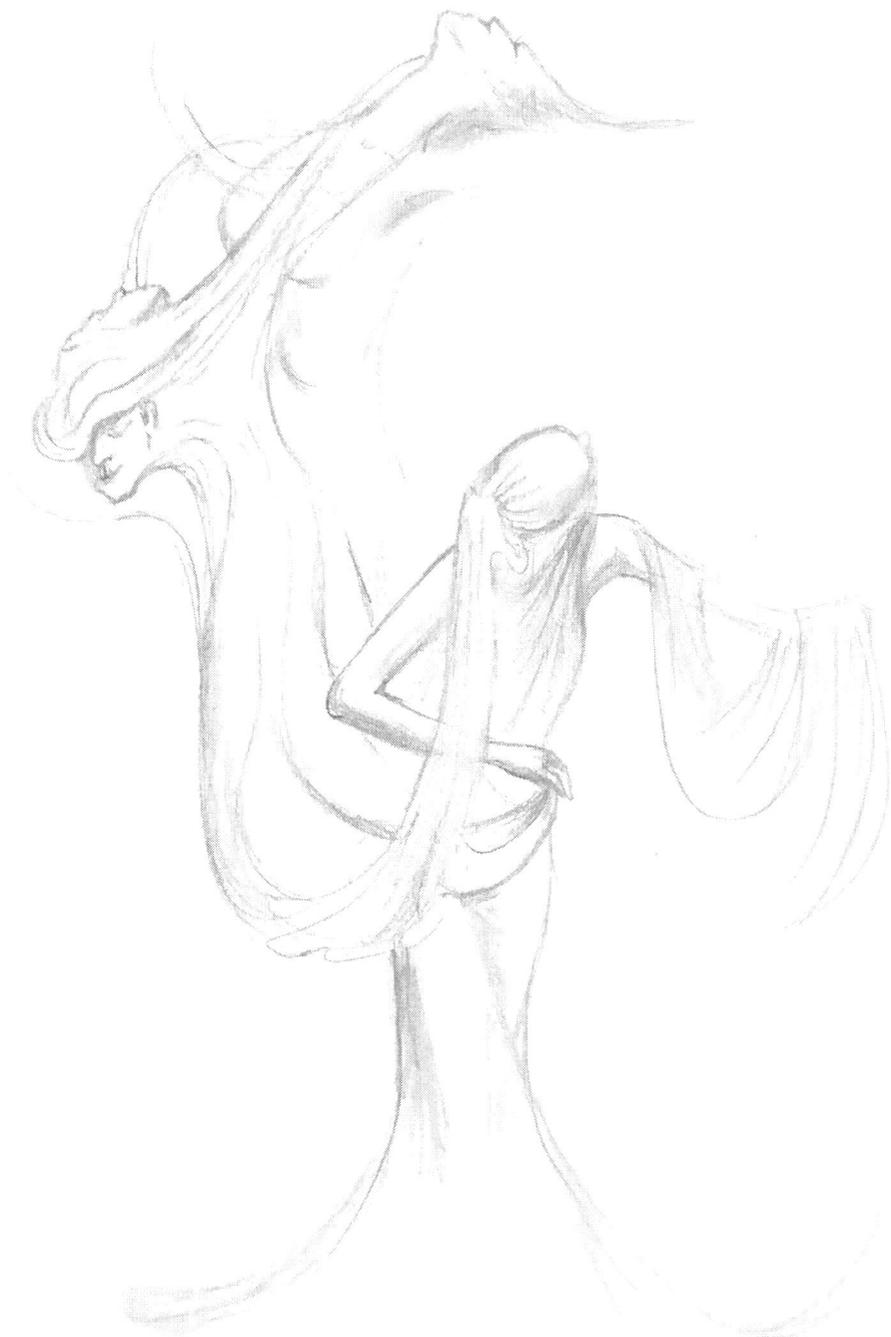

I love you doesn't mean I want you for myself. I love you means I want to do whatever is in my power to help you flourish in every way possible; spiritually, emotionally, mentally, and physically. I love you.

|ERICA ROBIN|

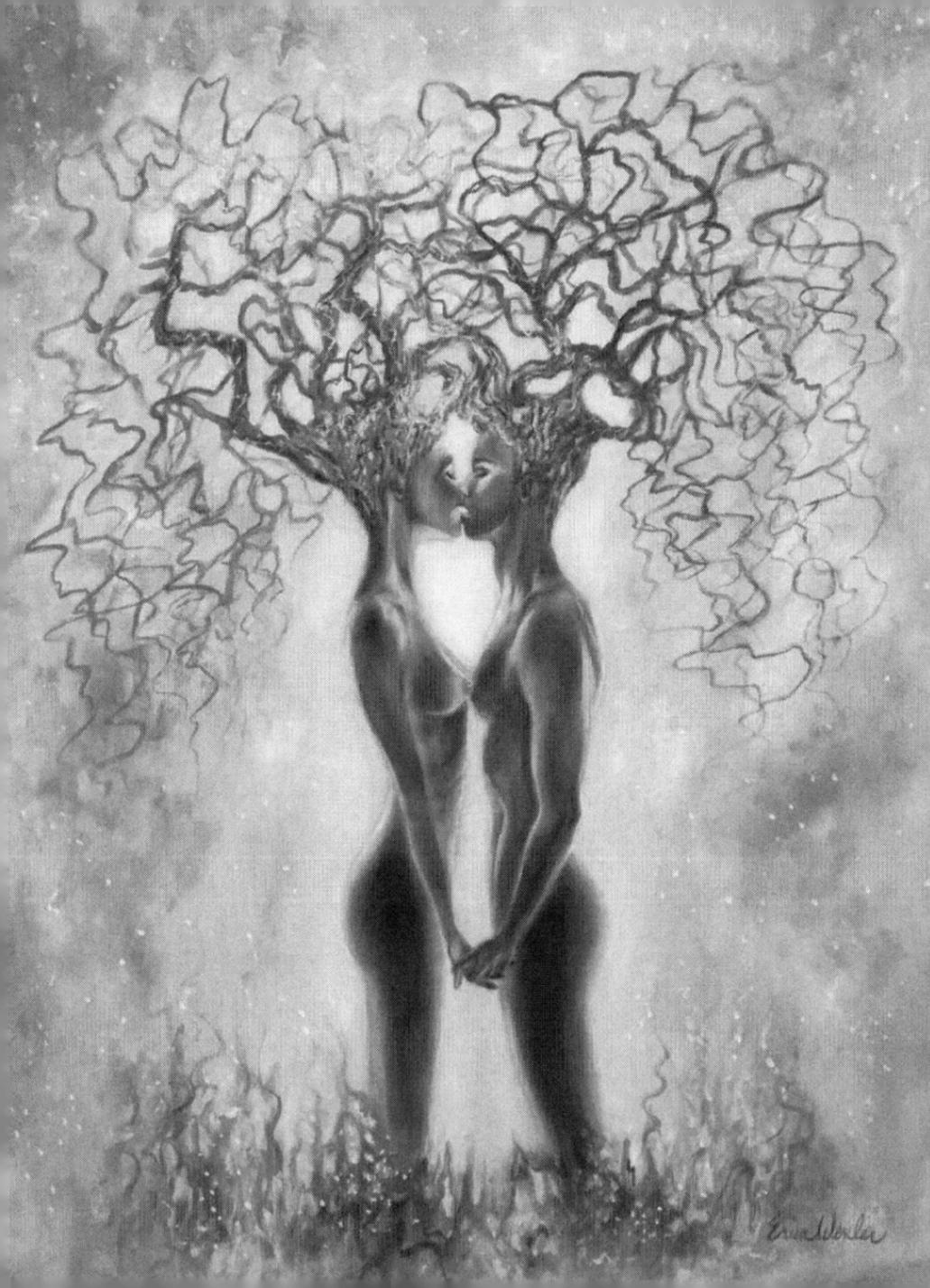

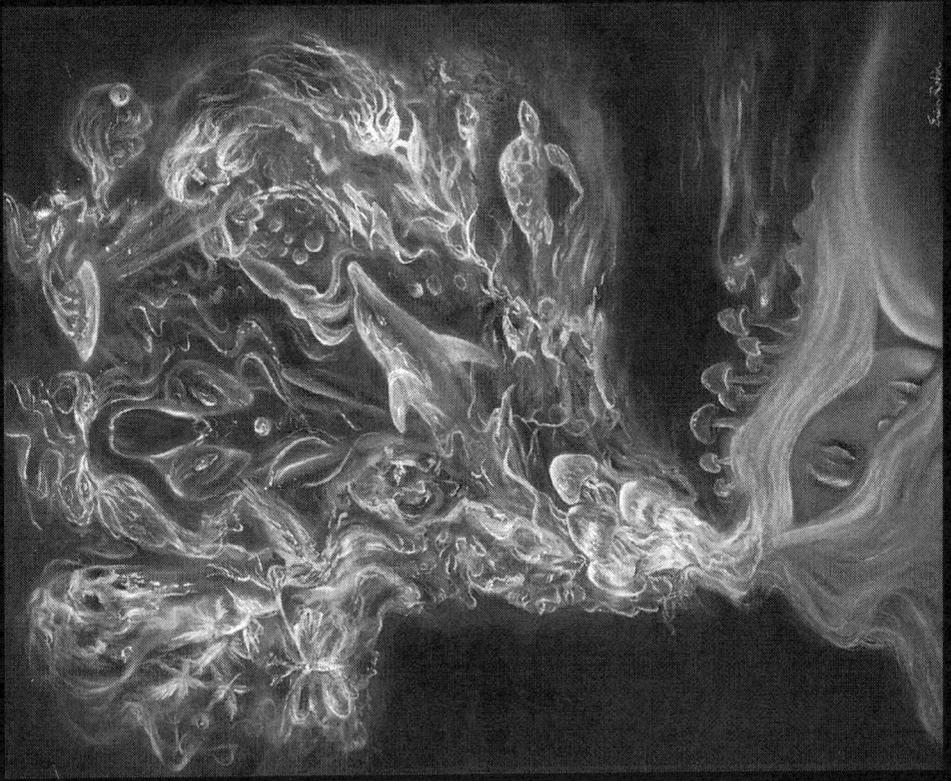
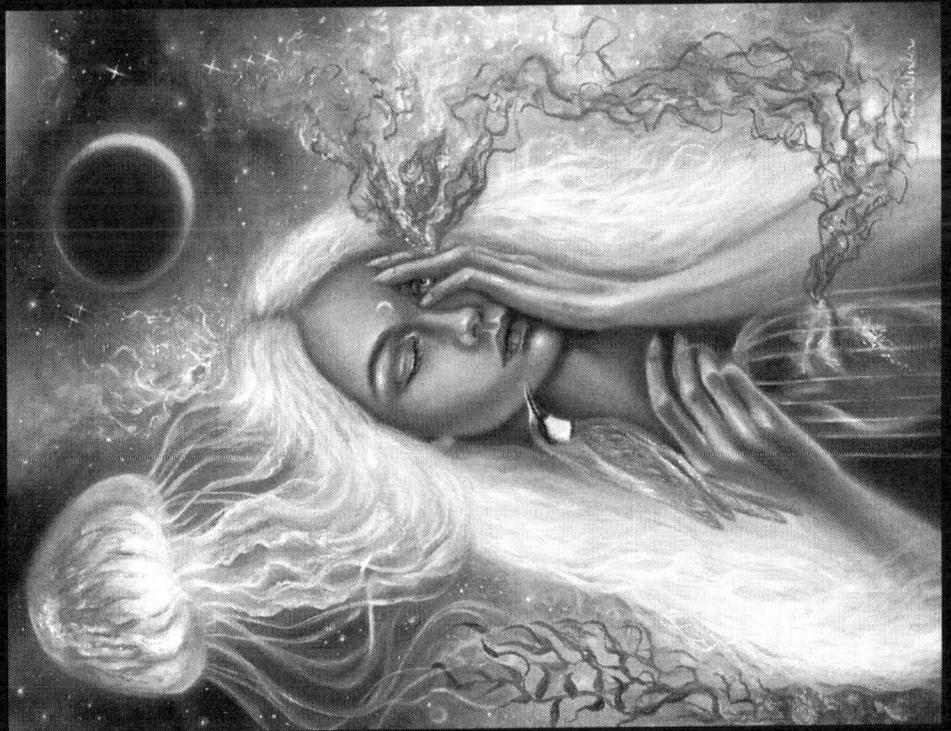

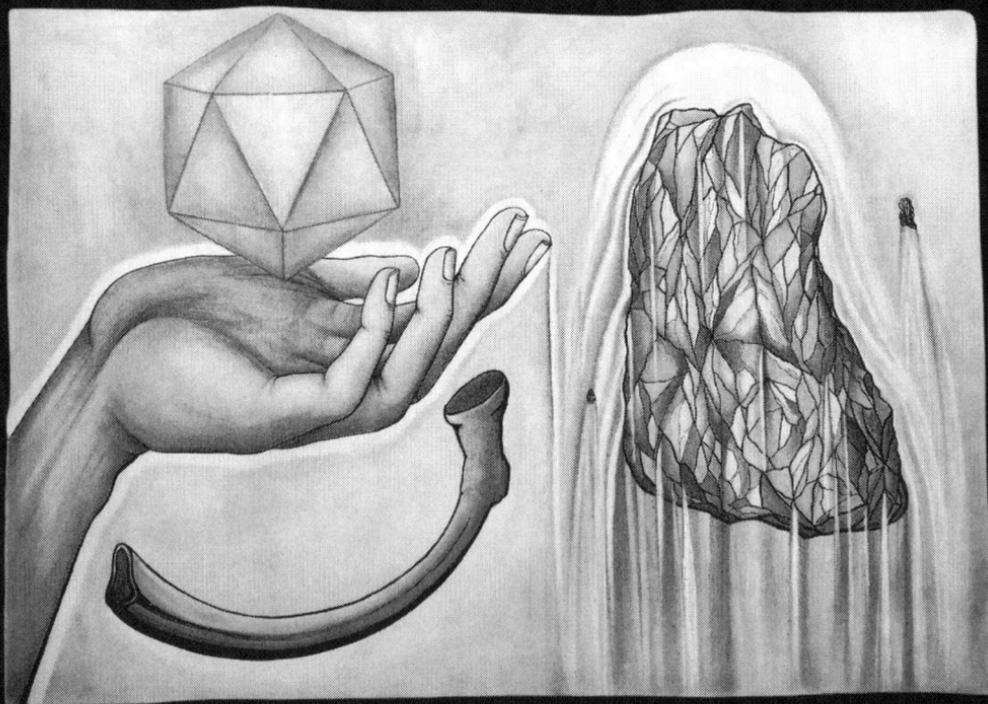

Straight from the mind, to the ink of the pen,
stained on the paper before you.

| NICK WORDEN |

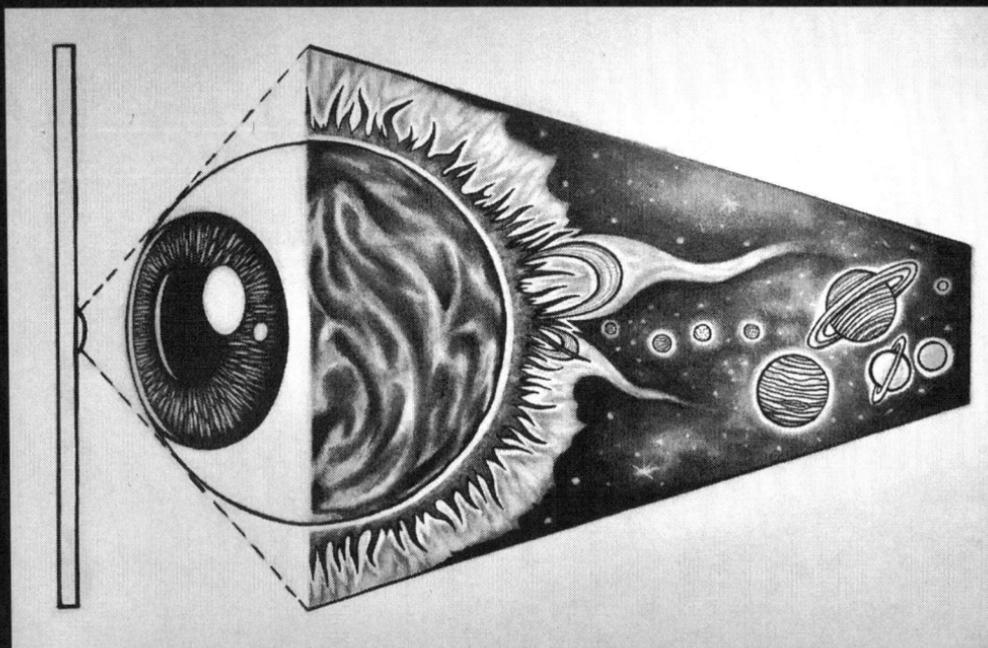

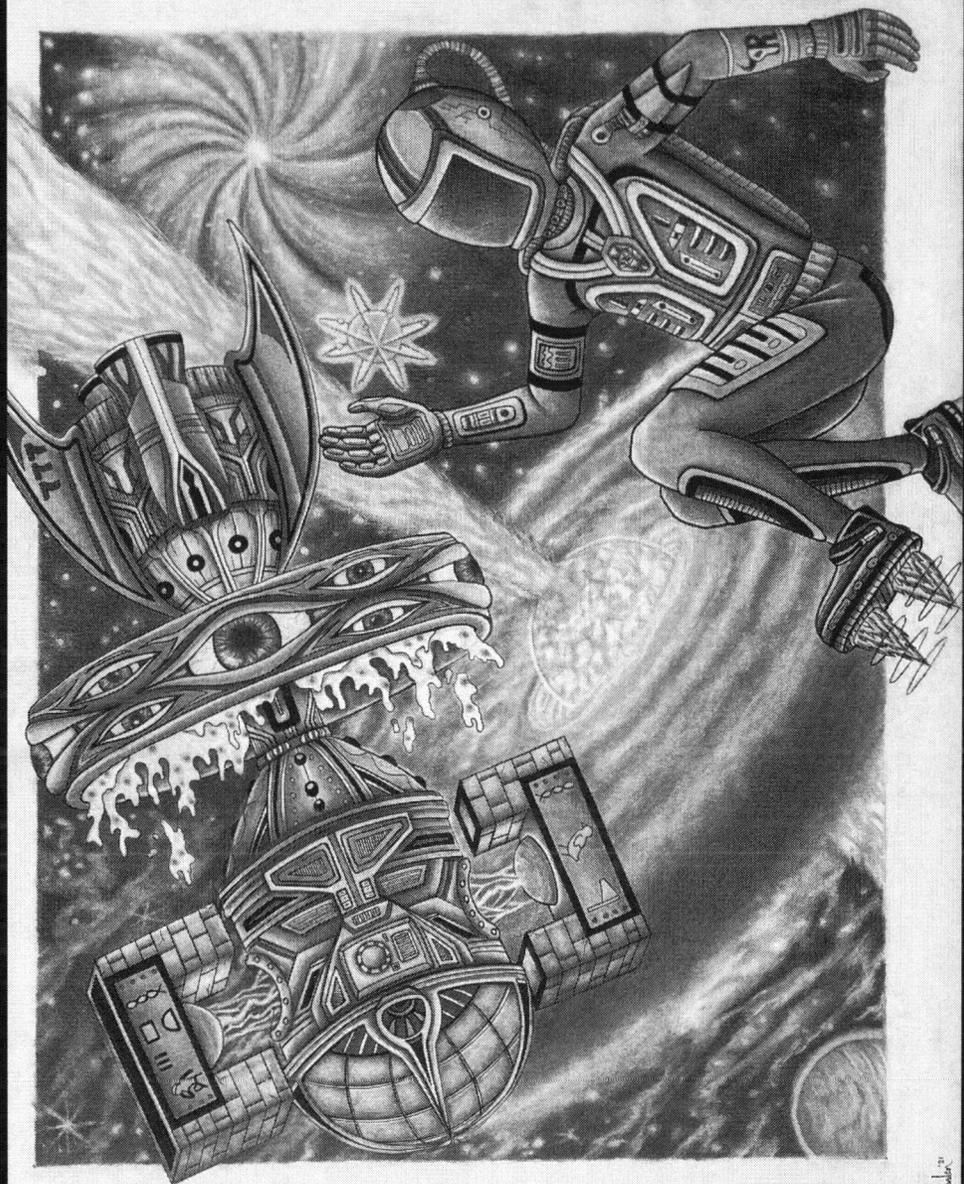

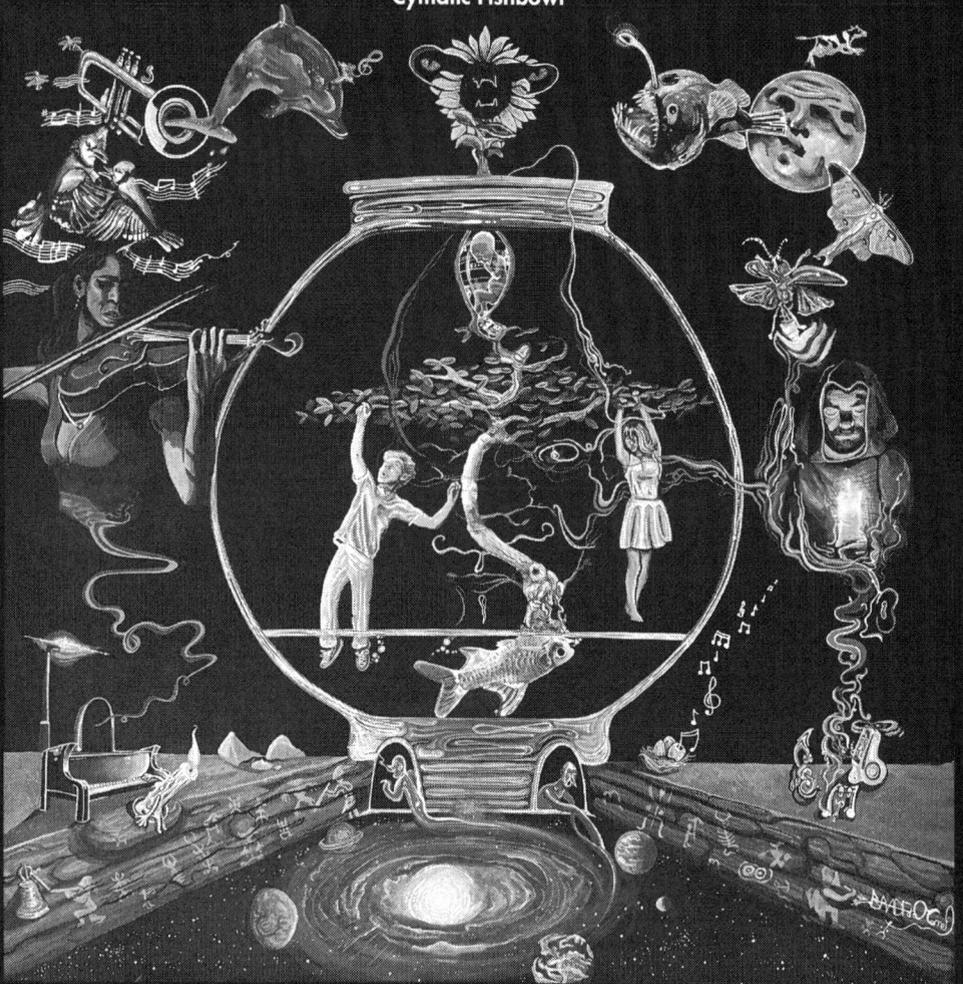

"Cymatic Fishbowl"

When you look at my work and ponder it. I'm trying to sell you on one thing. It's that this thing we call life. Well there's order to it and at the root of that order, there's a word! That word is AOM. The origin. This genie brings a primary trio of sounds. These sounds correlate to red, yellow, and blue. When mixed it becomes secondary and tertiary and resonates into all matter in existence. That matter is where we derive meaning. That meaning is consciousness. It's derived from the words, the story and the narrative. So here we are in this skit and what part do you wish to play. In an open sandbox where you are everything and everything is you. Do you wish to inflict suffering or bring forth faith, honesty and love. If you are it and it is you, born from the same source then with what will would pain inflicted be separate from you. With the proof of this revelation, what choice is there but to offer nothing but unconditional love. So with whatever creative outlet you choose to spread the word, make sure it's in the image of the one who created first. With what land could you stand on to build if not for the one who gave us ground? When you believe in this divine creator you gain purpose, faith and honor even when eyes aren't watching. With character comes innocence, the intuition that guides us is the sense built in. With true instinct comes gods voice. When it's audible there is guidance. Believe, do good onto others, and create. Your path will clear up no matter how murky.

| BRADFORD O'CONNELL |

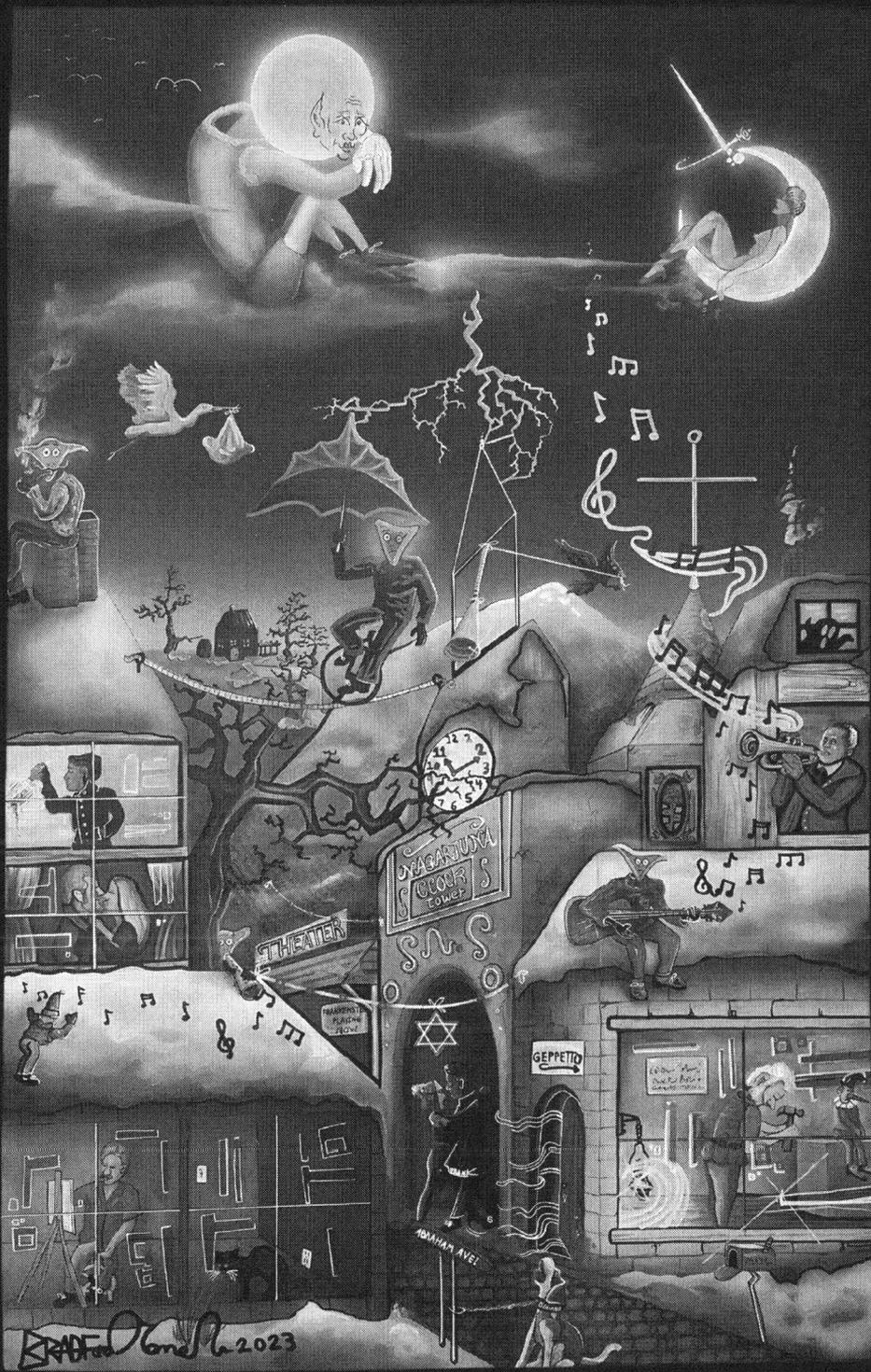

"AOManate the Luminescent Boy"

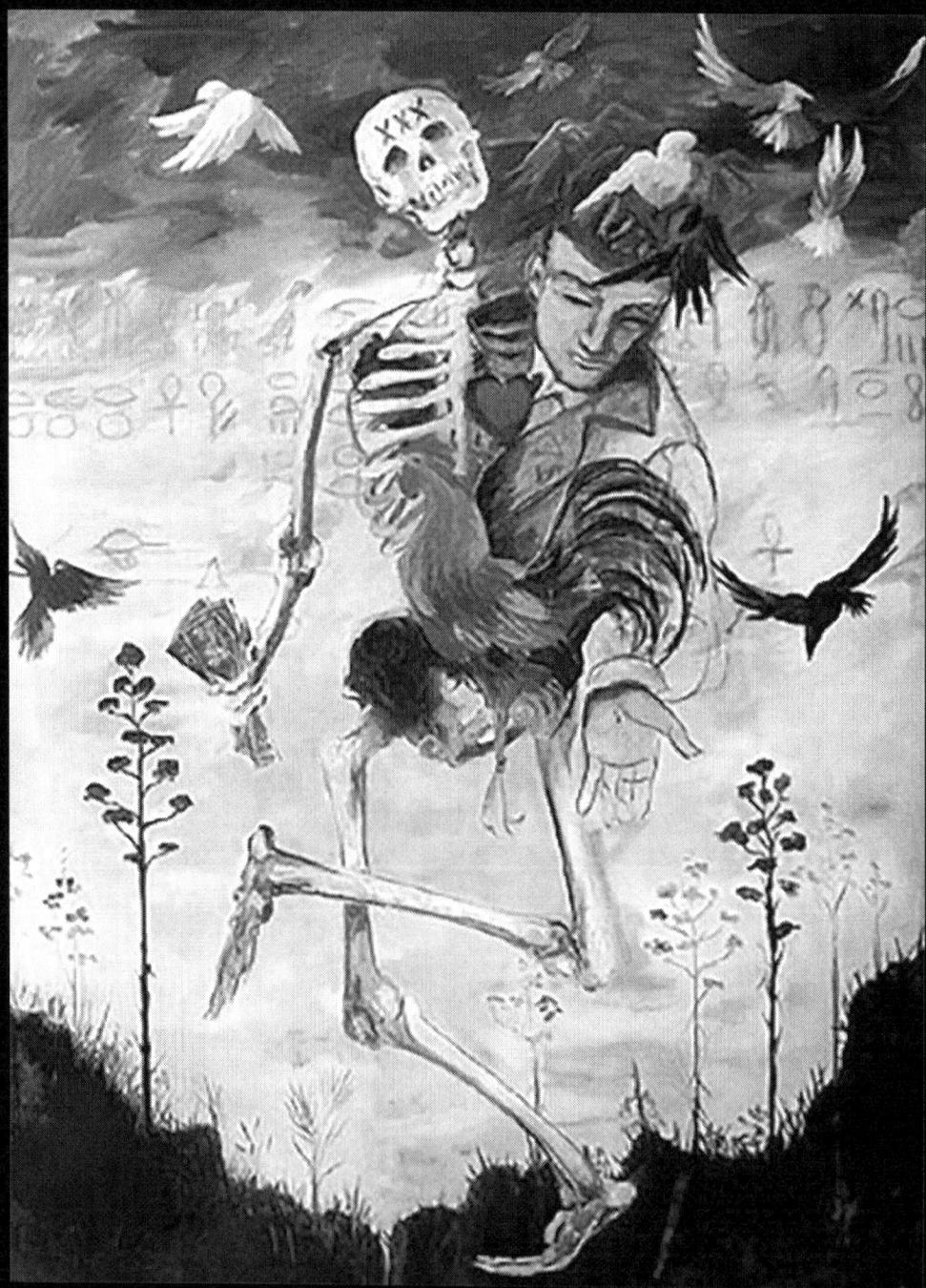

Consider shape, line, color, and acquiescence in sync.
Light upon shadows in your genius.

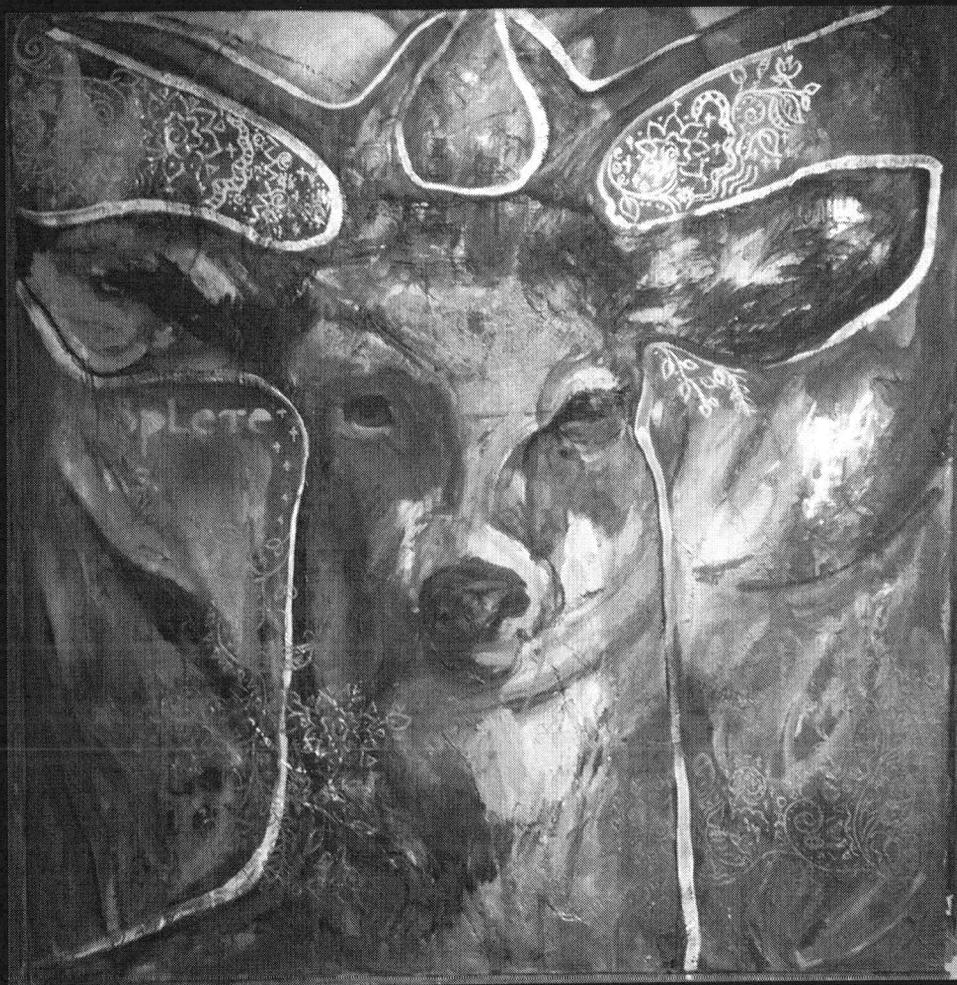

|WHITNEY FOX|

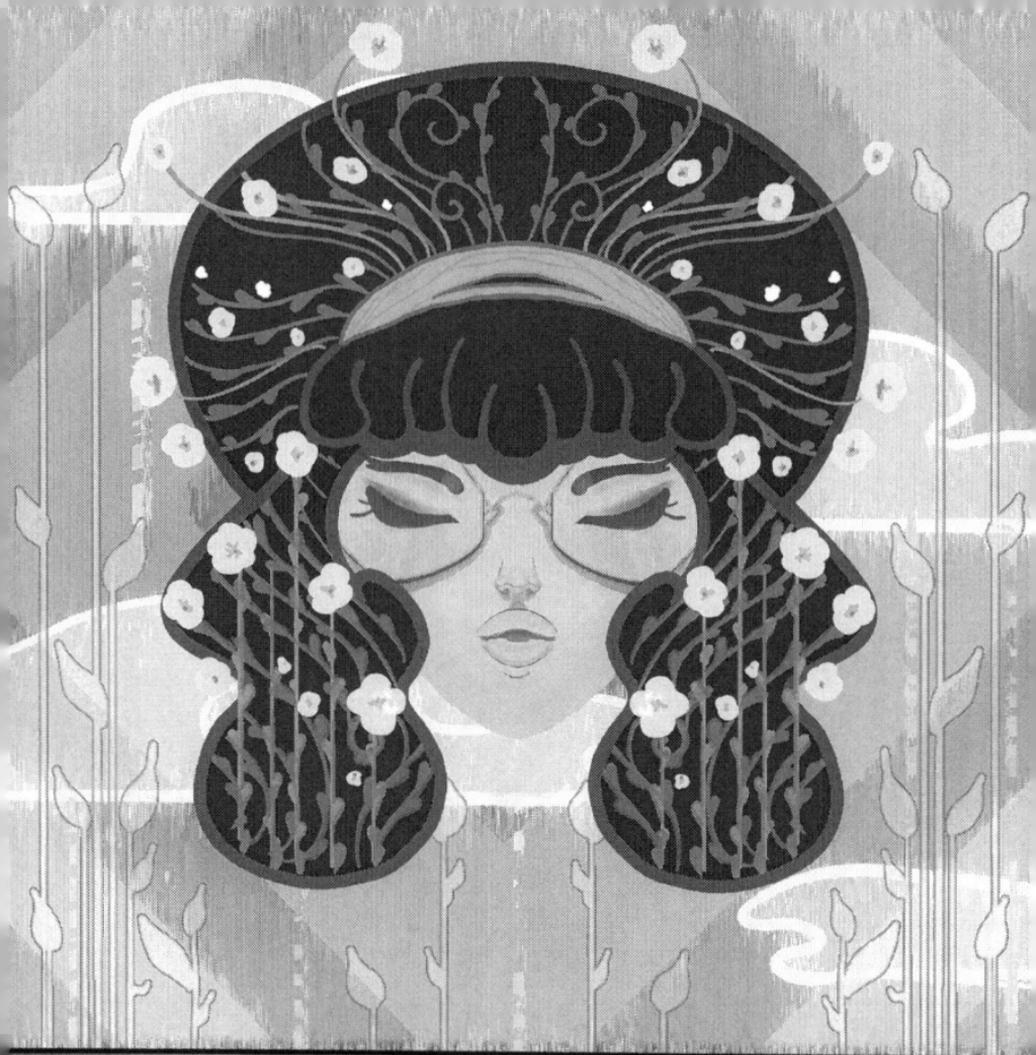

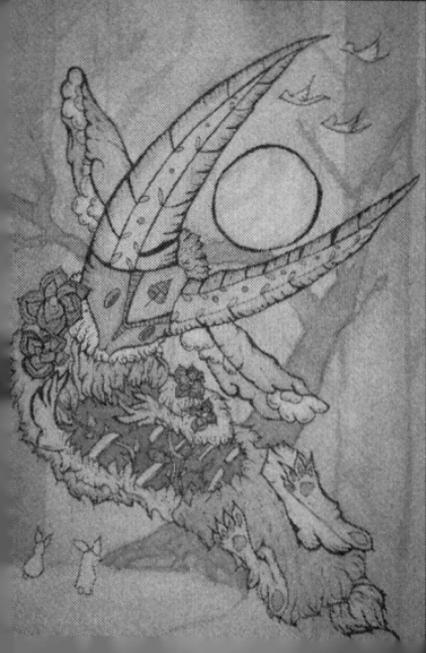

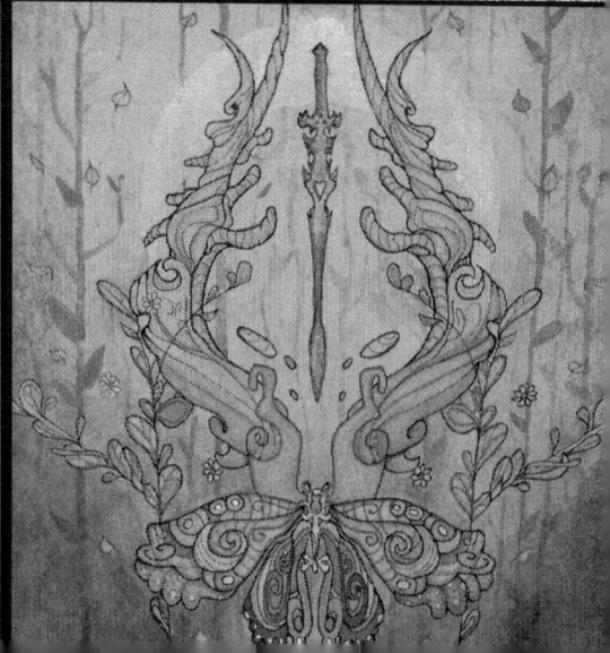

To me Creating is like cloud gazing - Ideas slowly pour over the canvas that change shape, lose form, and become transfigured over their travels. It's up to you to define what it is, and to decide what that journey means. With each discovery and new facet of what you hadn't noticed before, the image unfolds before you, to become the creature in the clouds you had always seen.

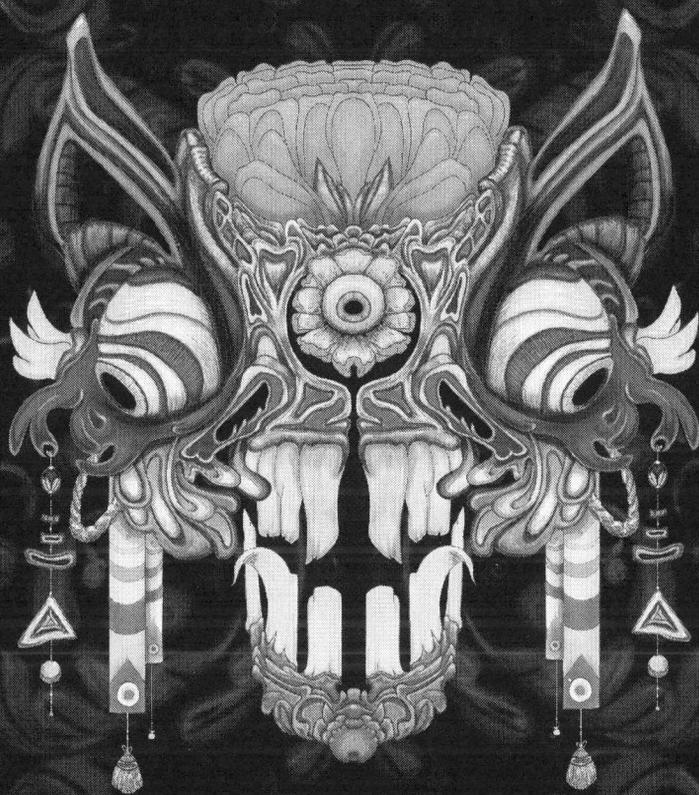

| JUDE STARLING |

color me.

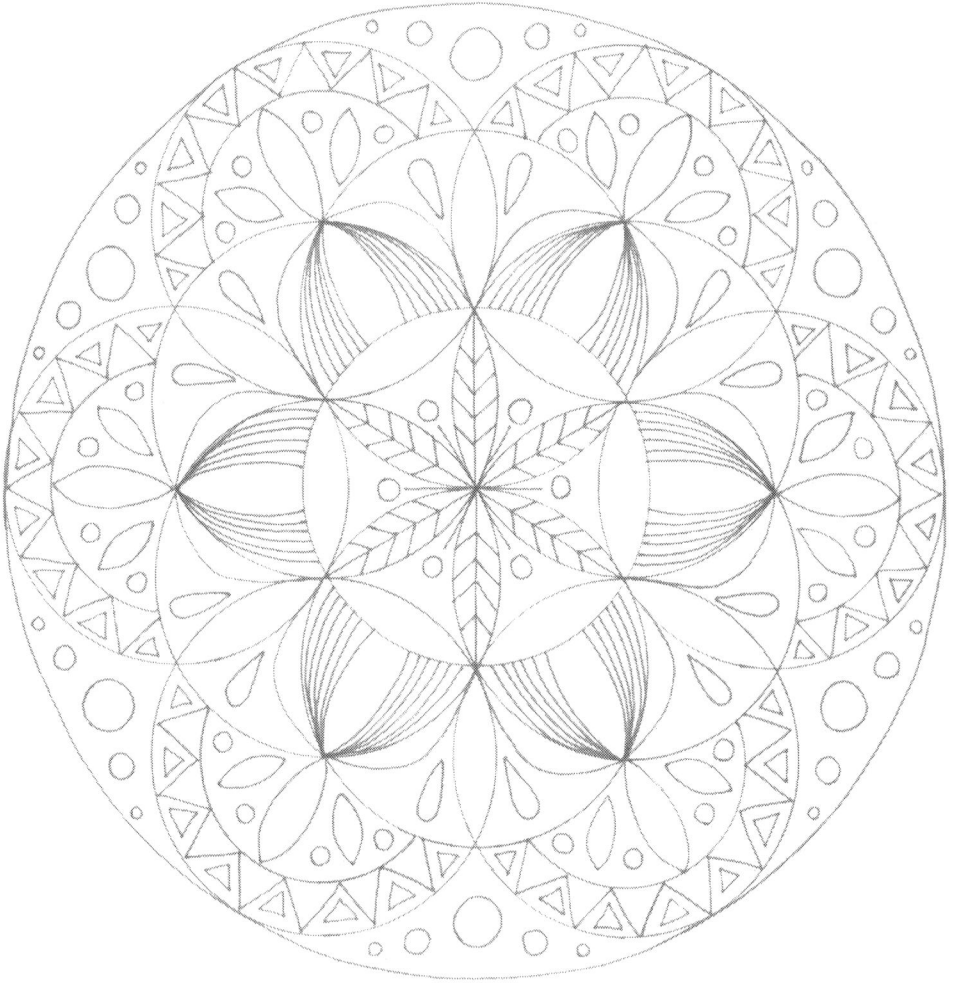

|JEANNINE BURGESS|

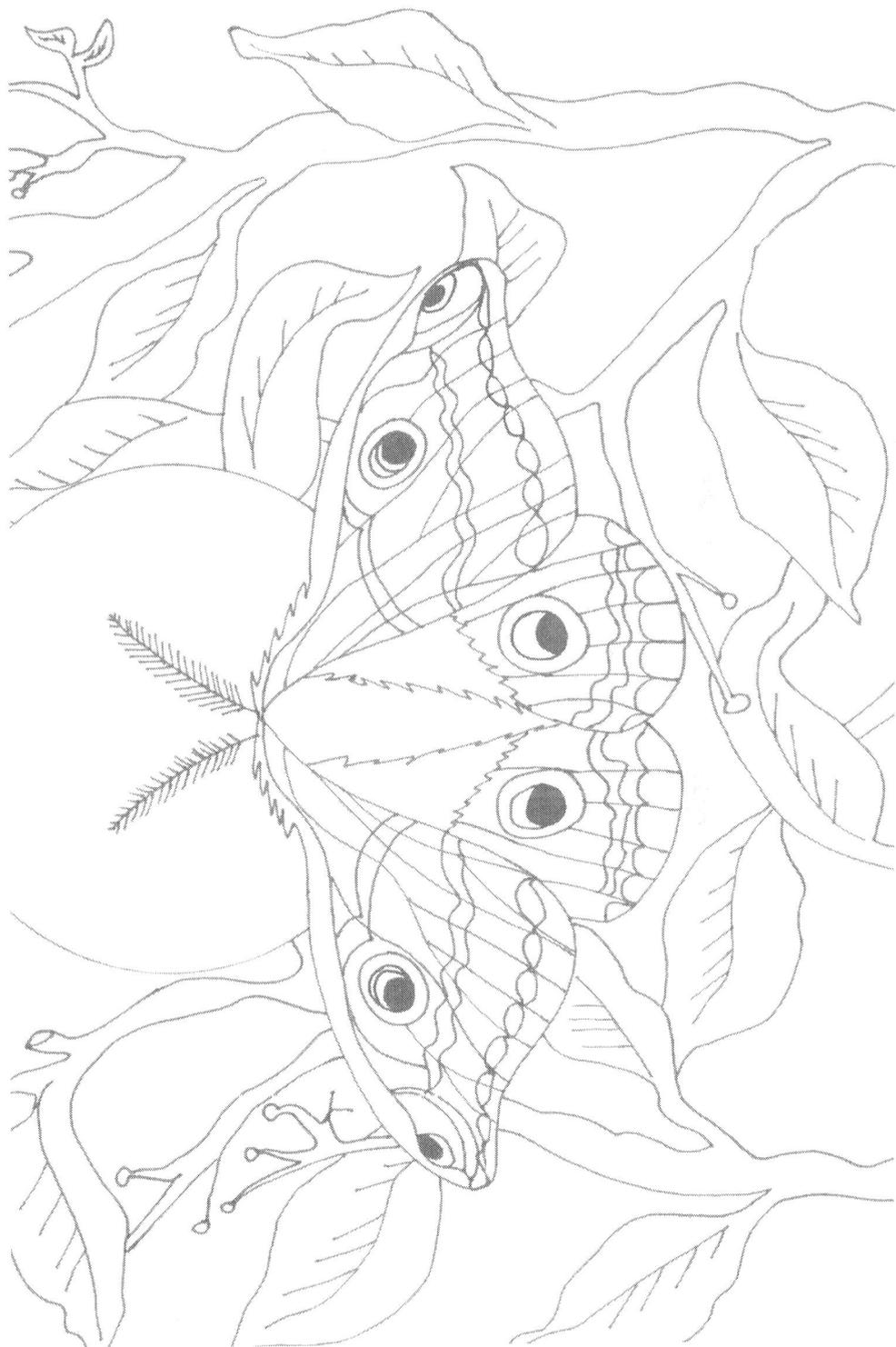

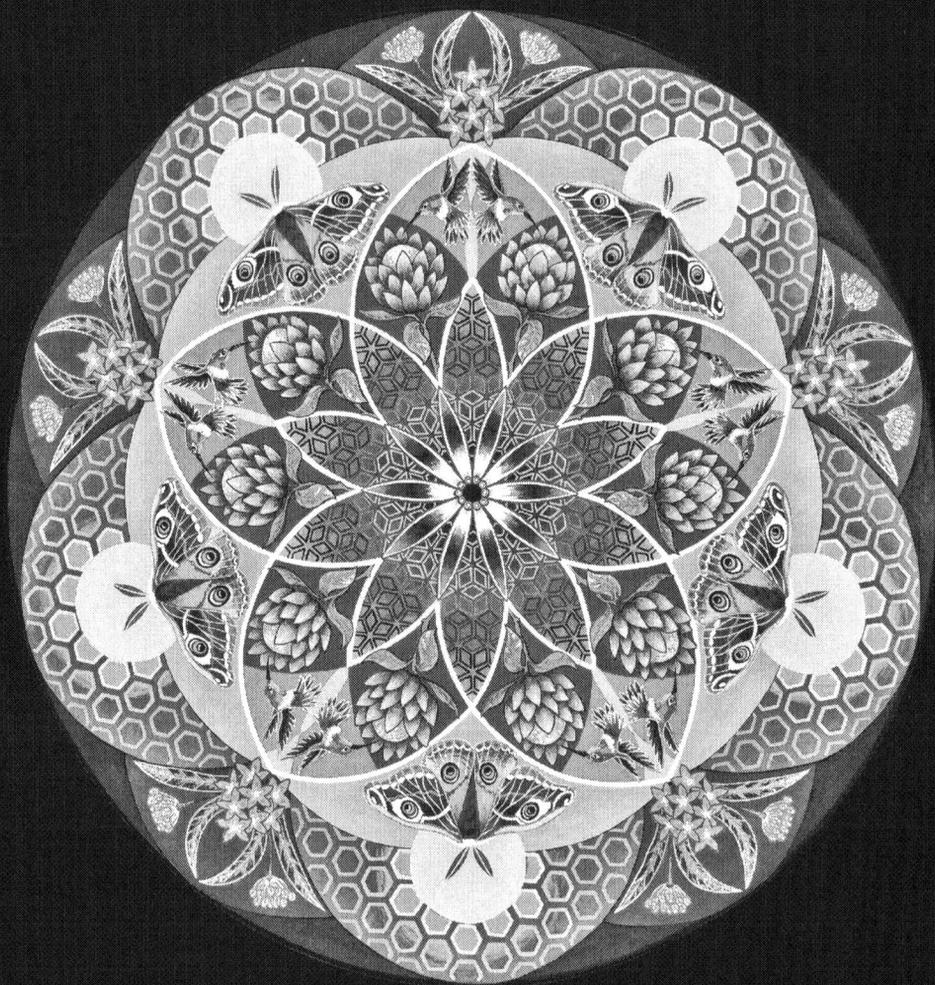

|JEANNINE BURGESS|

When you begin to explore your creativity through the intentional kaleidoscope of shapes and colors, you start a journey of connecting into your intuition. You unearth deep parts of self that have long been hidden. You begin to see with full clarity what lights you up, and what doesn't. Follow that light, and your whole life will change.

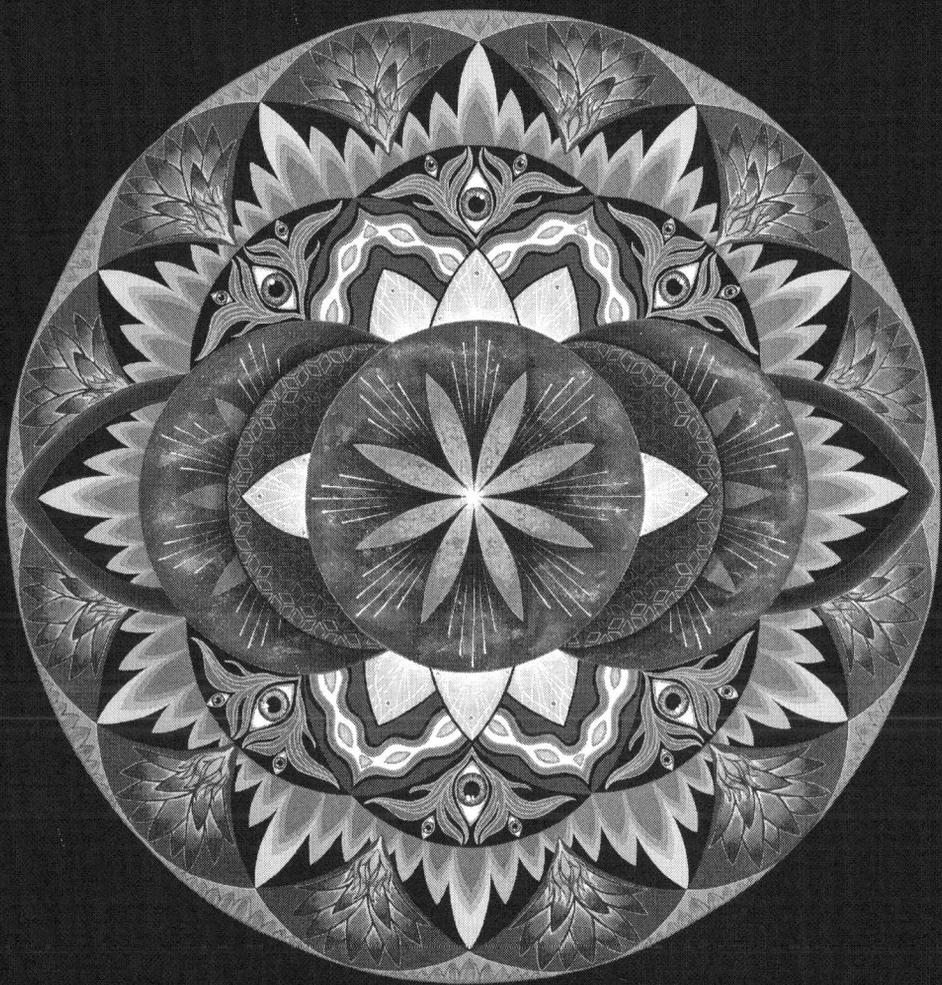

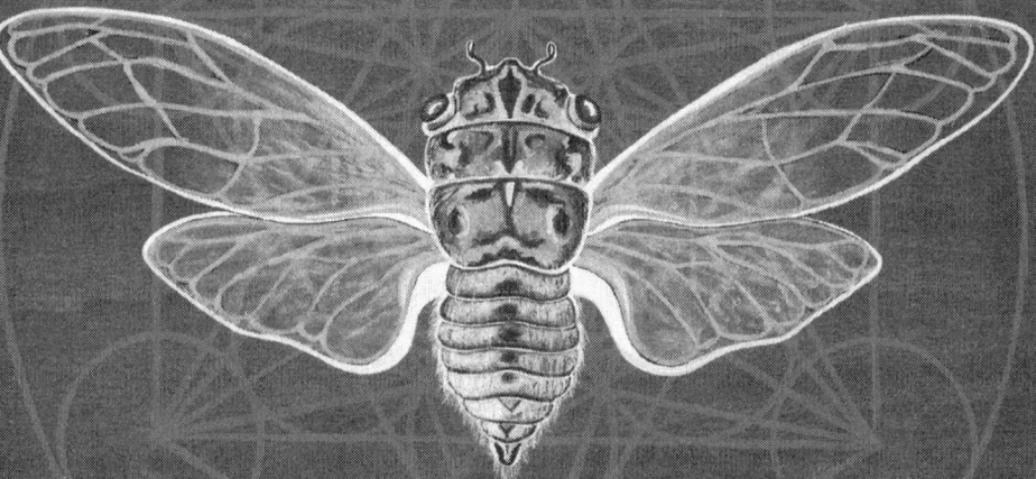

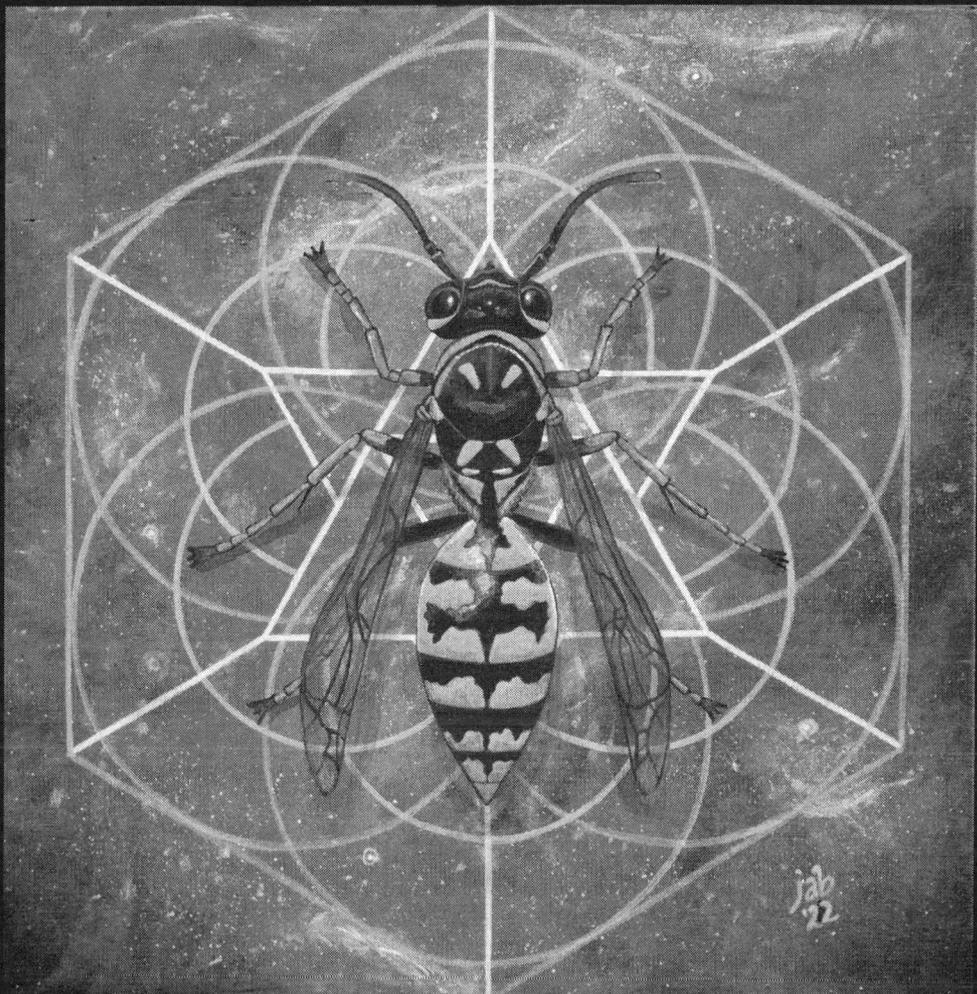

| JEANNINE BURGESS |

Creativity is a portal to deeper
understandings of Self.

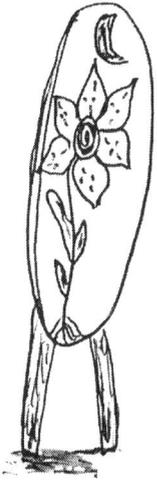

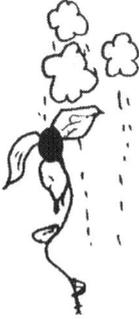

| MARISA LOVE |

I art sometimes.

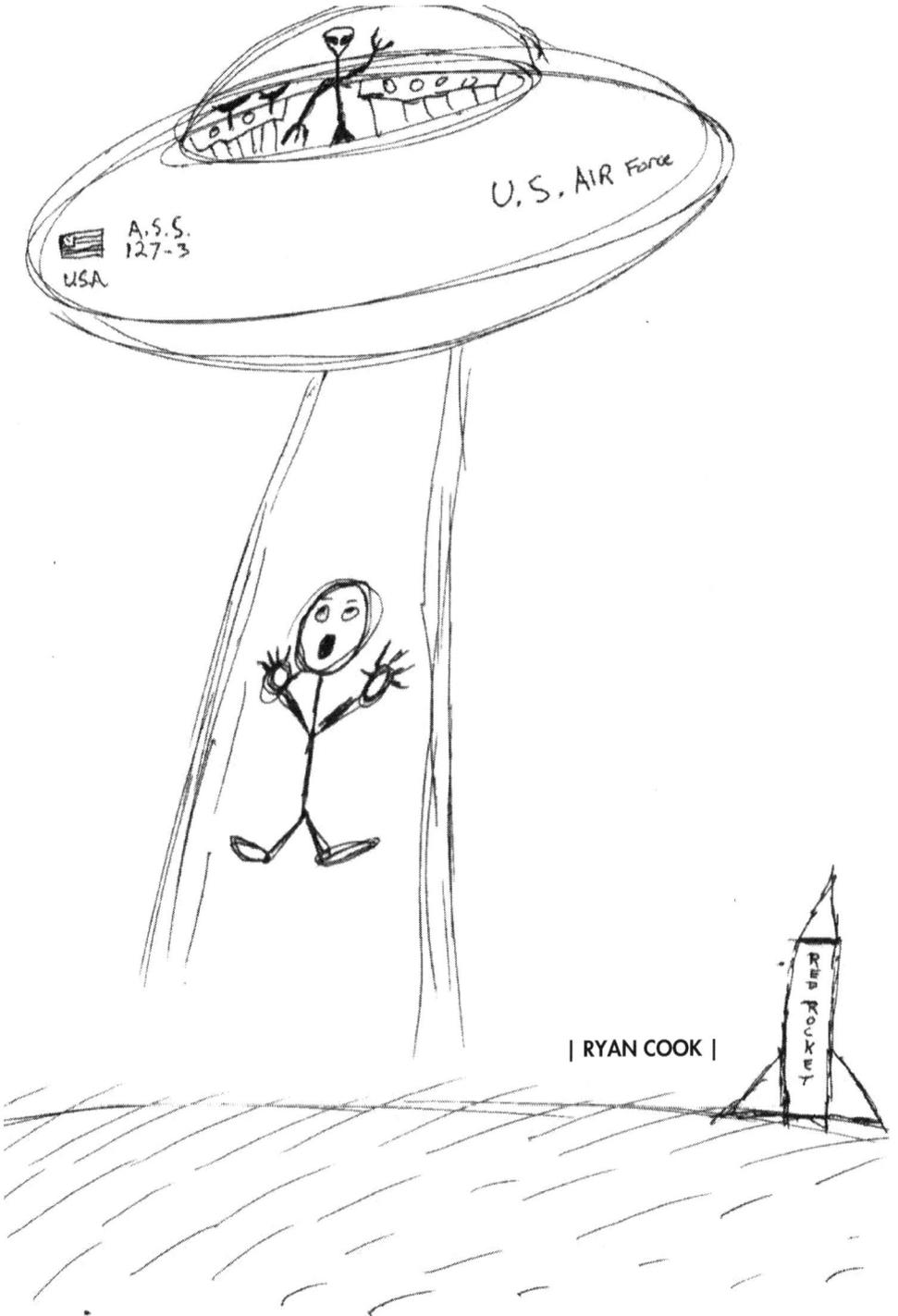

| RYAN COOK |

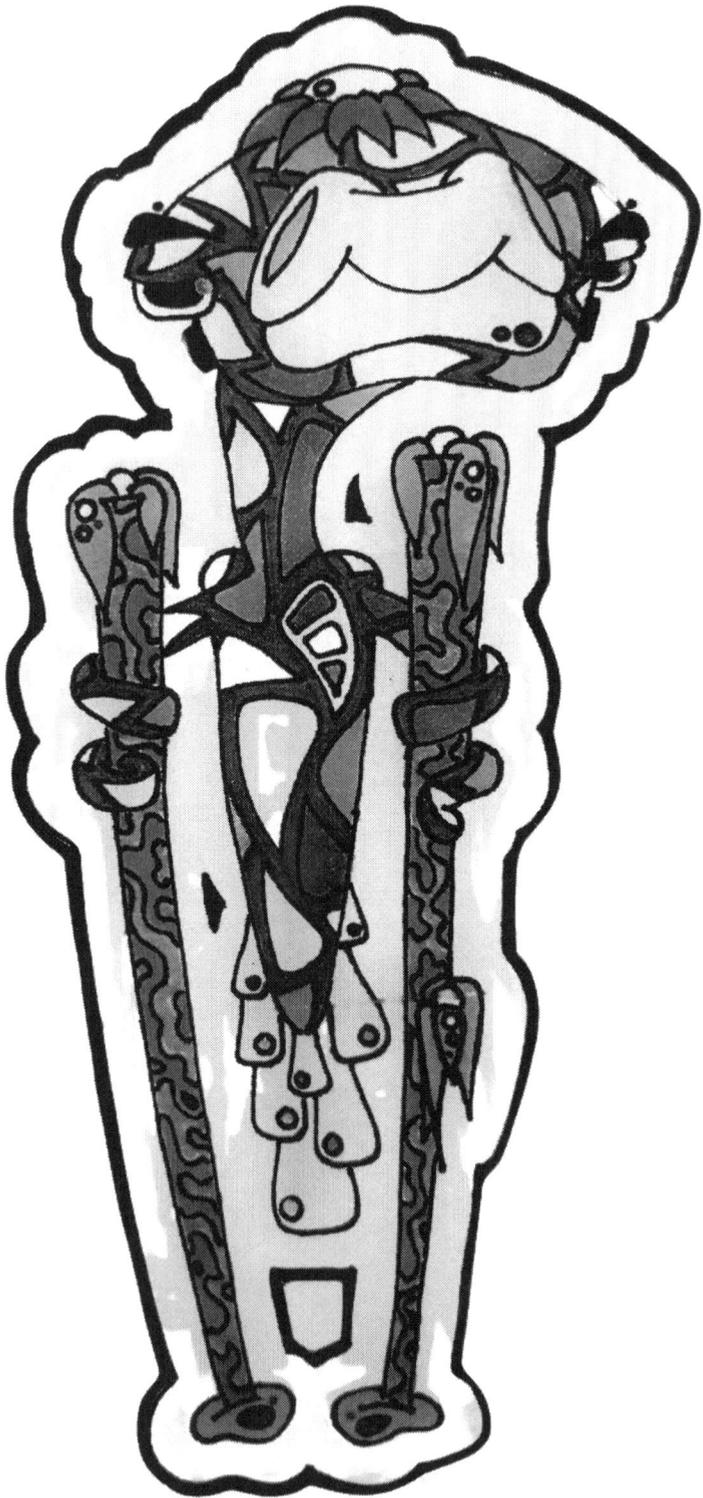

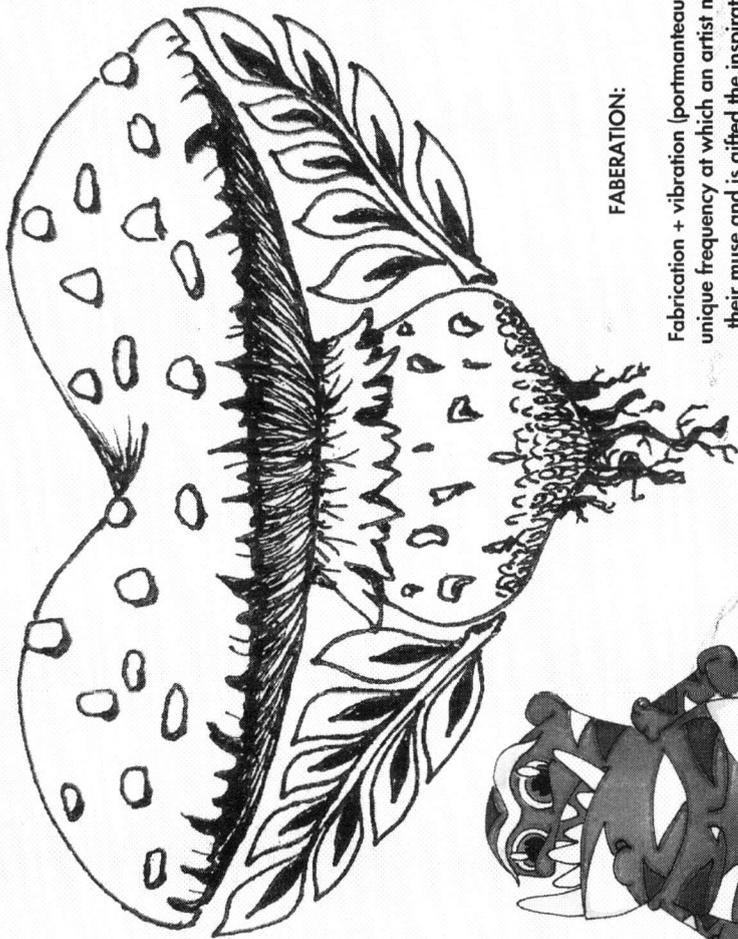

FABERATION:

Fabrication + vibration (portmanteau) the unique frequency at which an artist meets their muse and is gifted the inspiration and drive for the fabrication of fabulous, divine creatons.

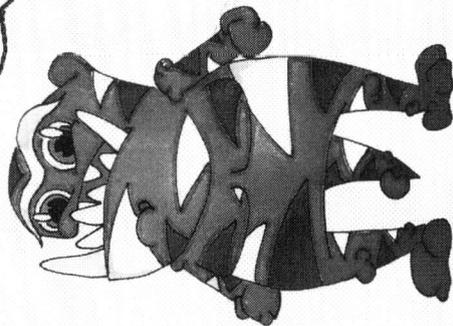

| KELLI HARDING |

Art is always a path towards knowing ourselves better. In reality, we are all students. The only difference is that some don't know it yet.

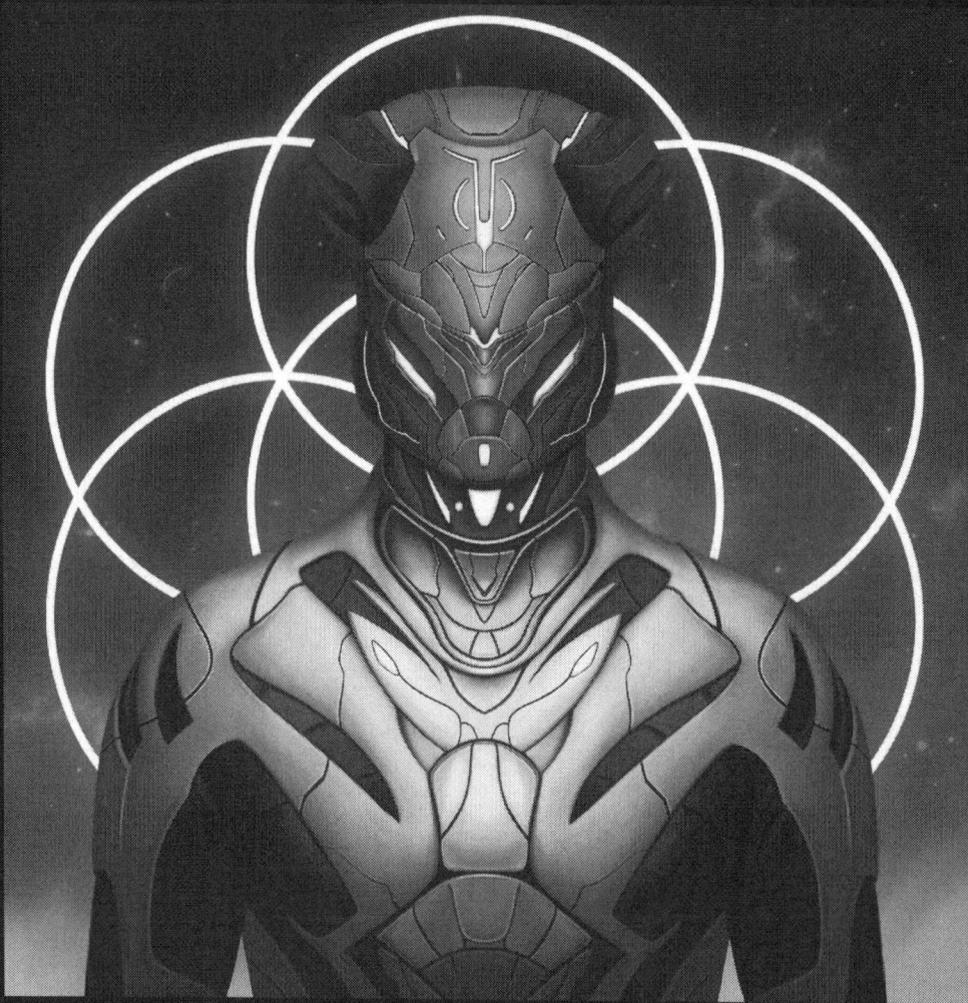

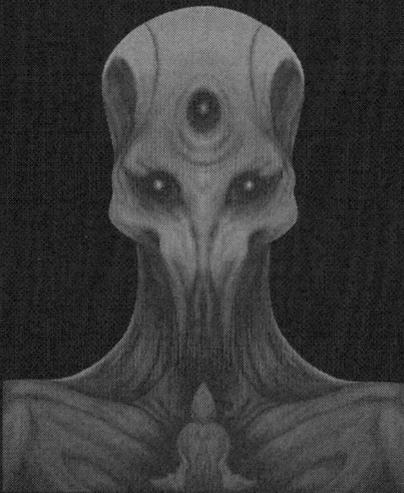

| ANTHONY STUART |

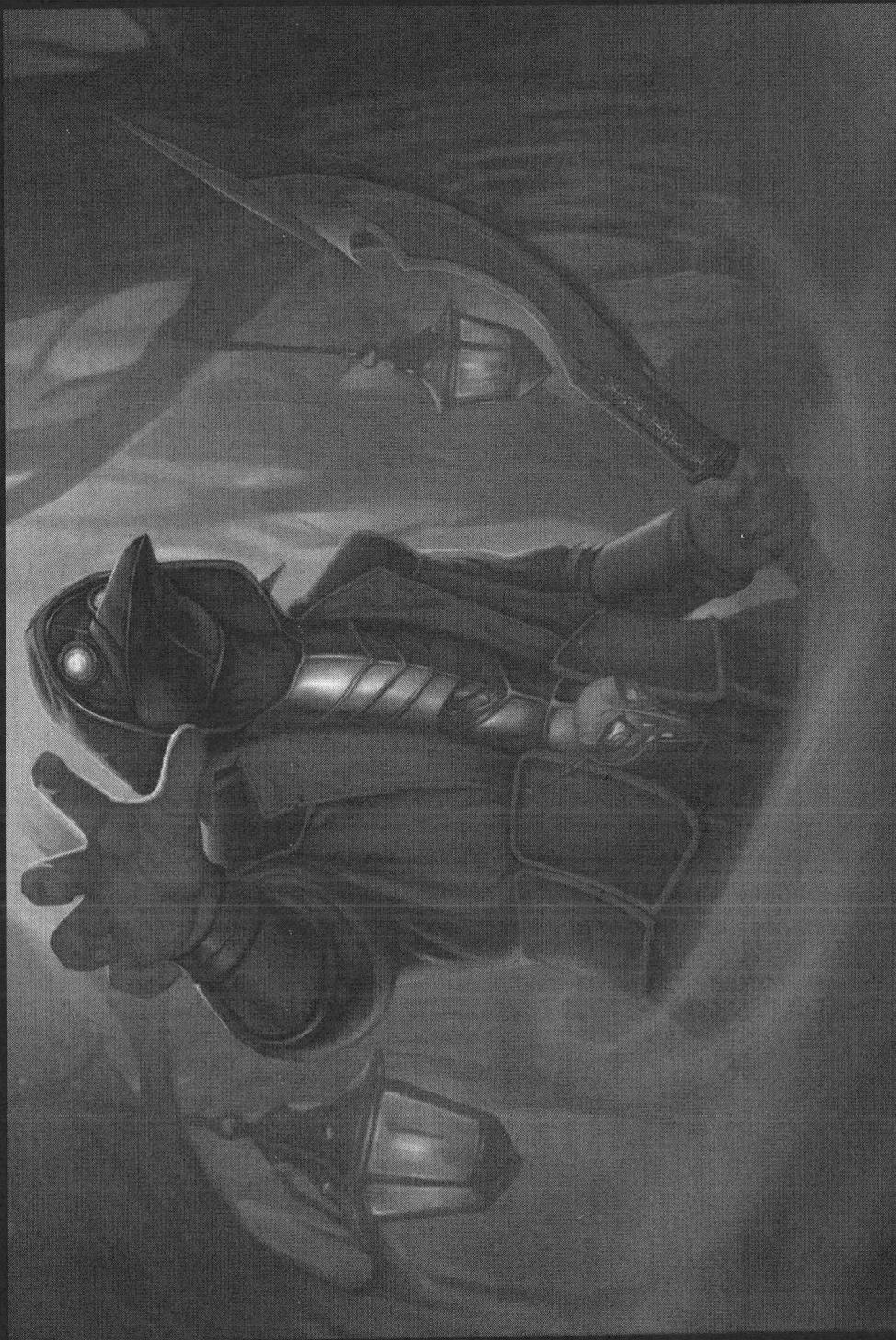

Sfincks

It's not a waste of time if we're having fun.

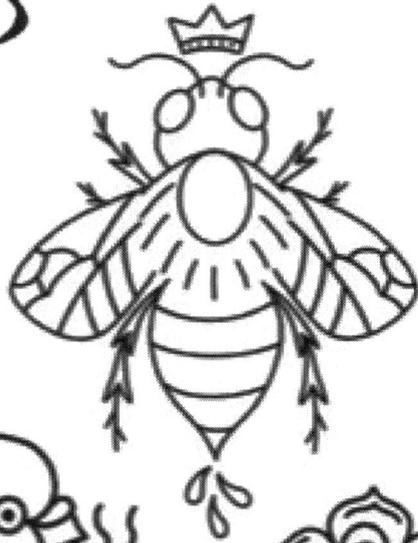

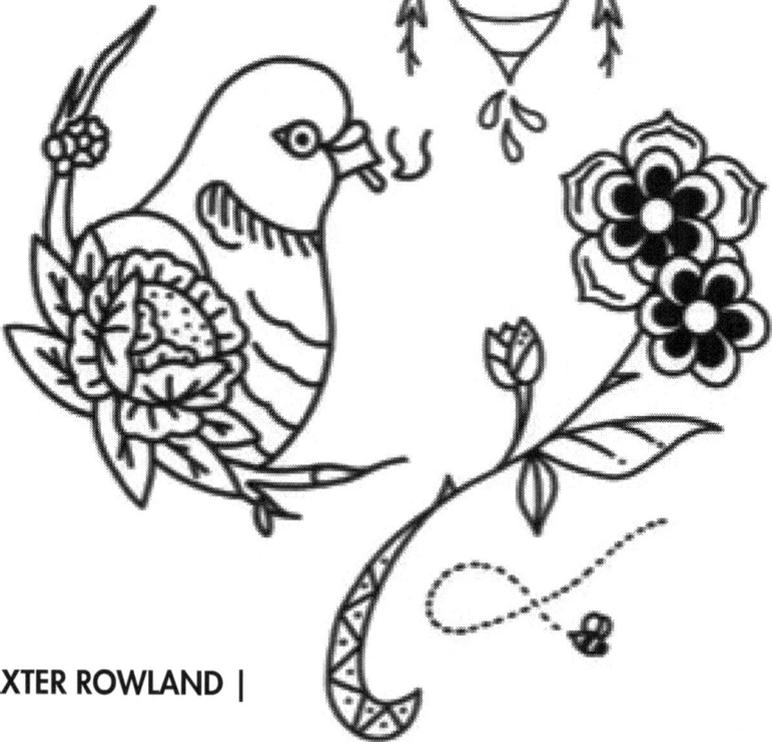

| BAXTER ROWLAND |

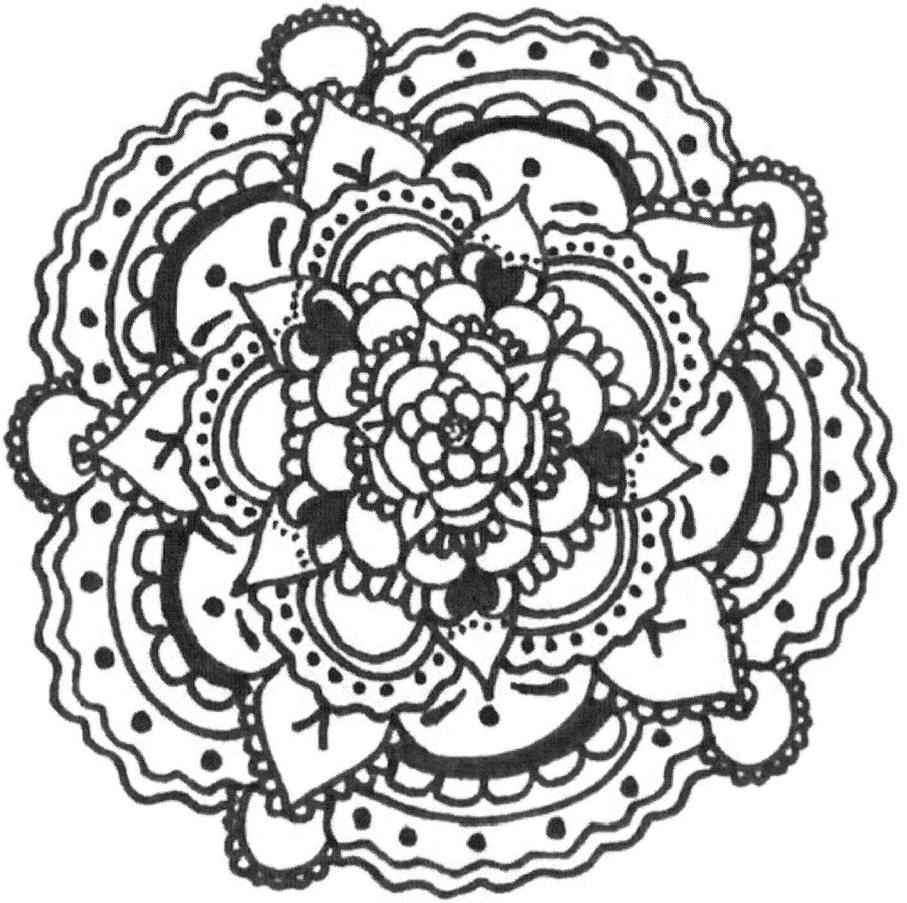

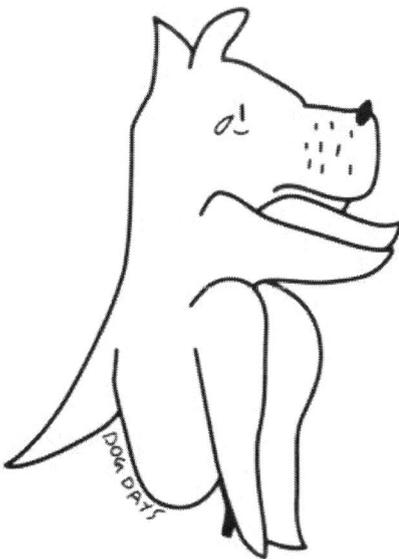

"It isn't that bad, you will find another day that's better." - Caroll Spinney

| MIA JO ROWLAND |

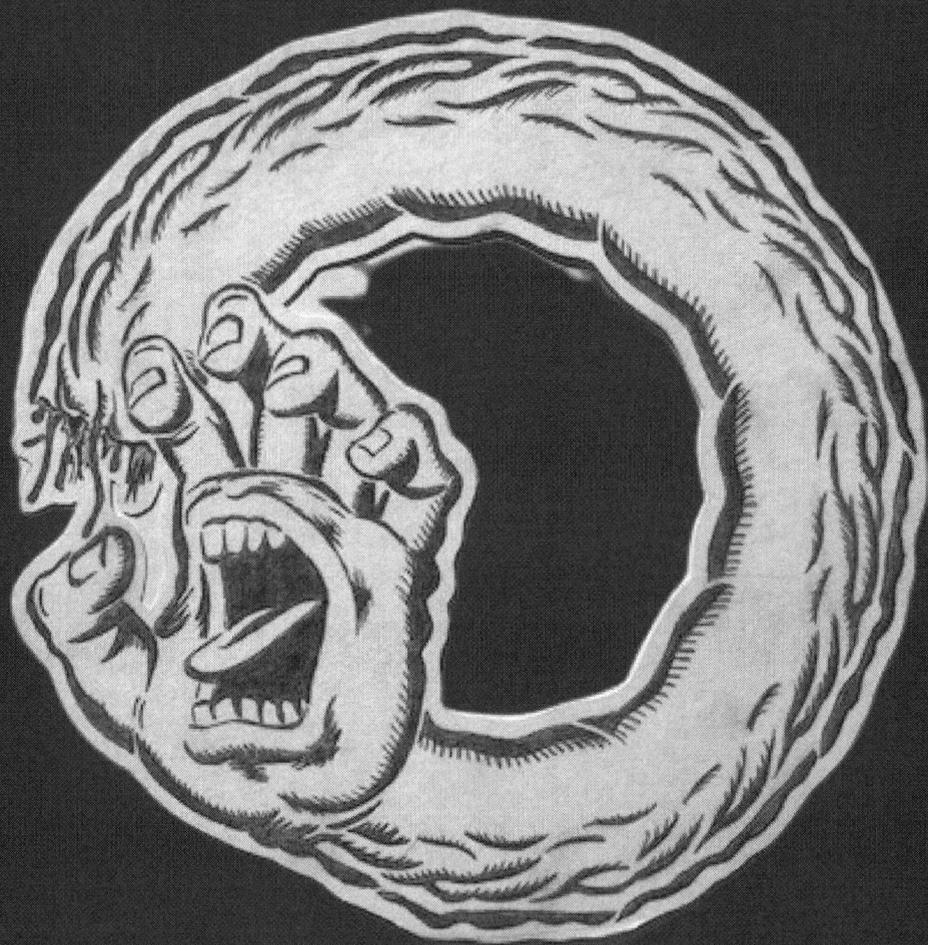

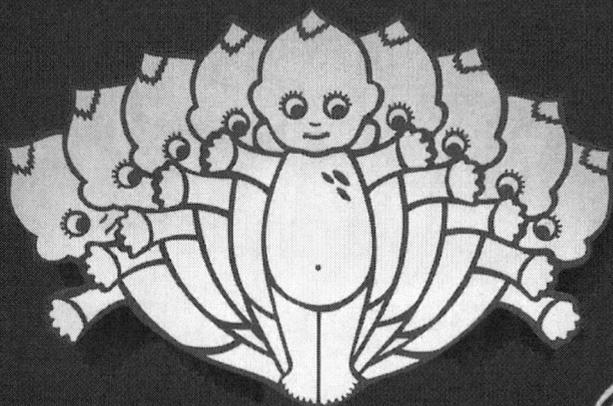

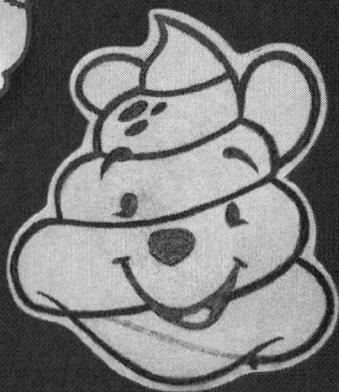

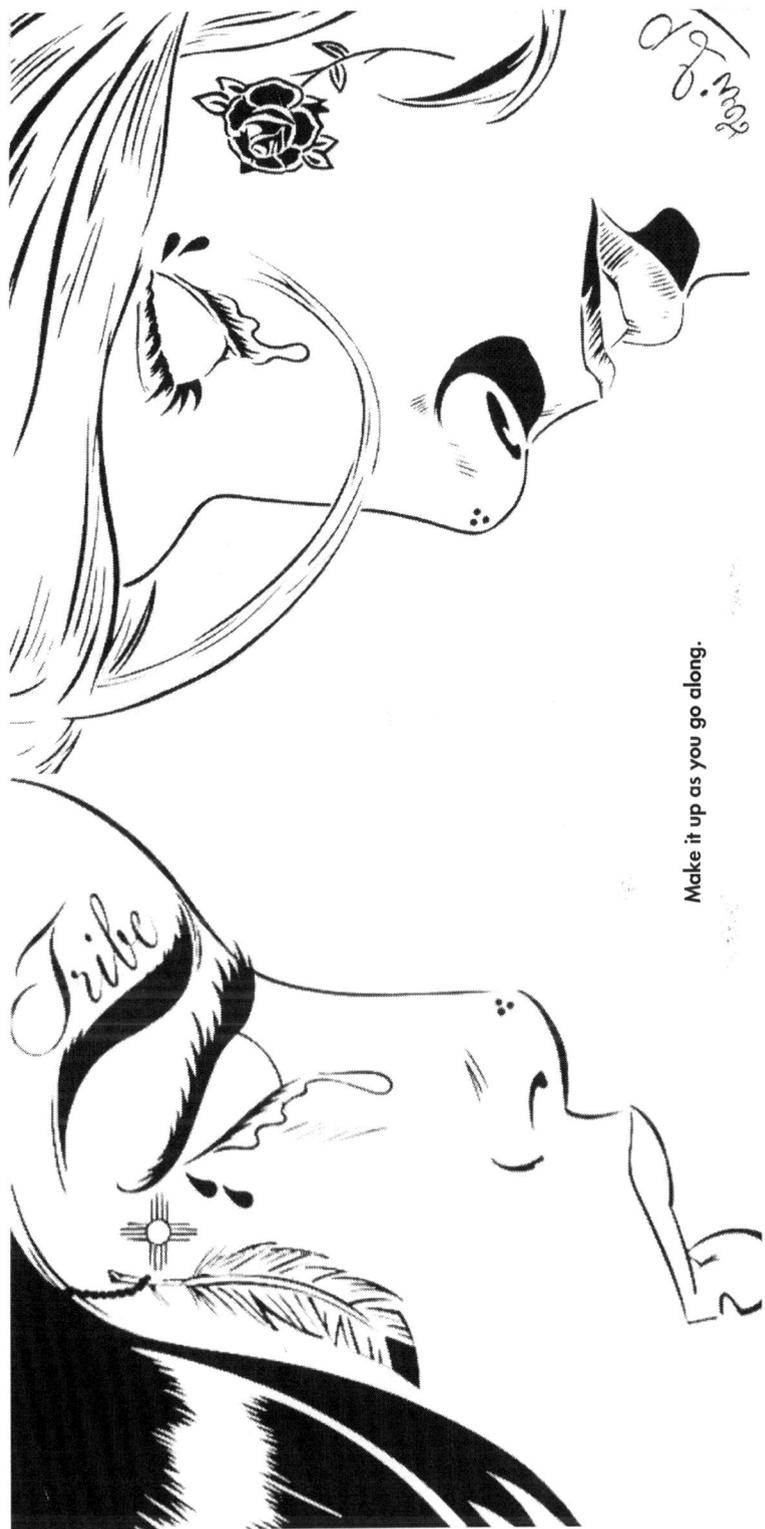

Make it up as you go along.

| JASON ROWLAND |

FACING our fears Makes US greatest version of Ourselves.

| GERI DILLON |

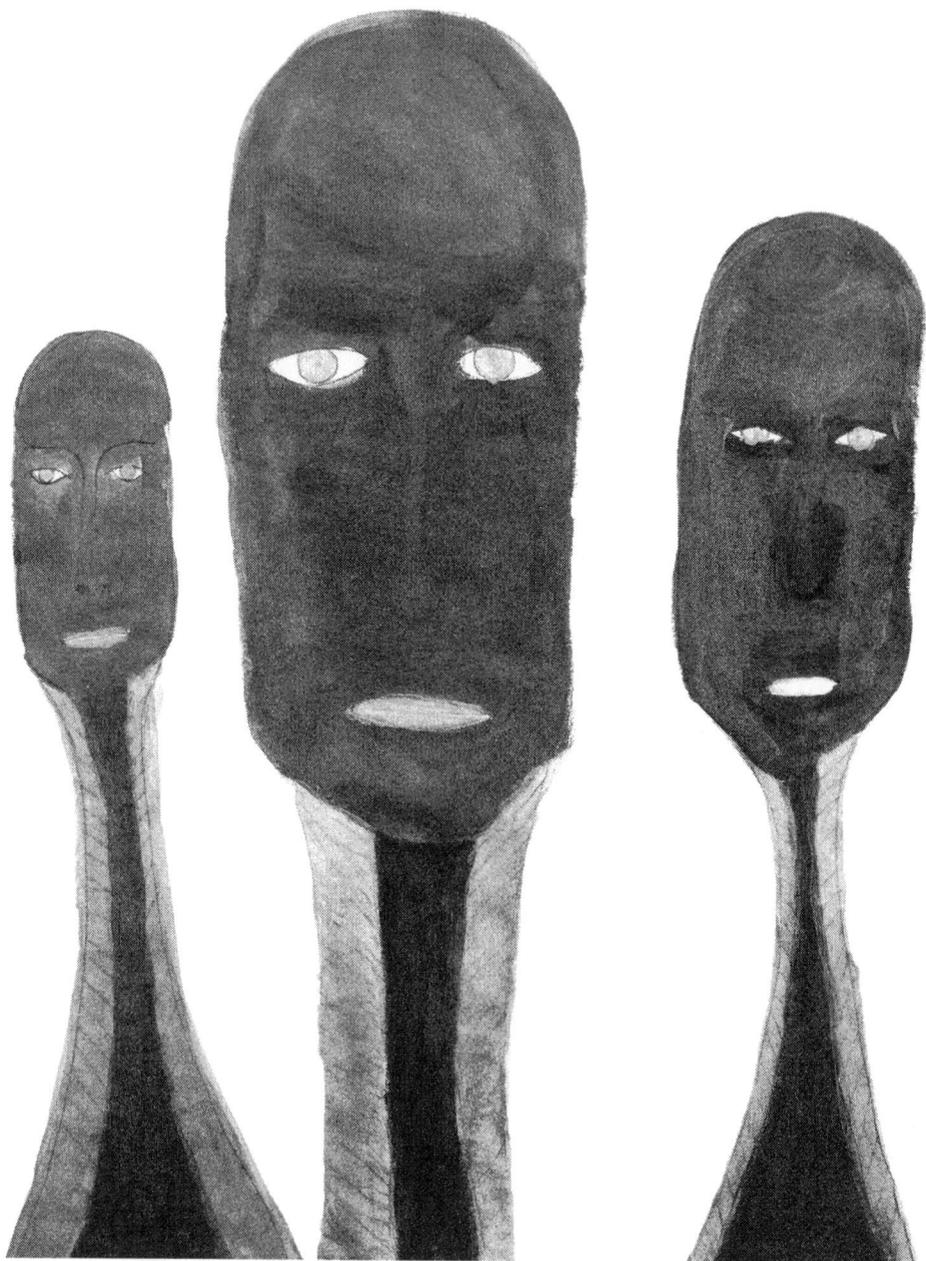

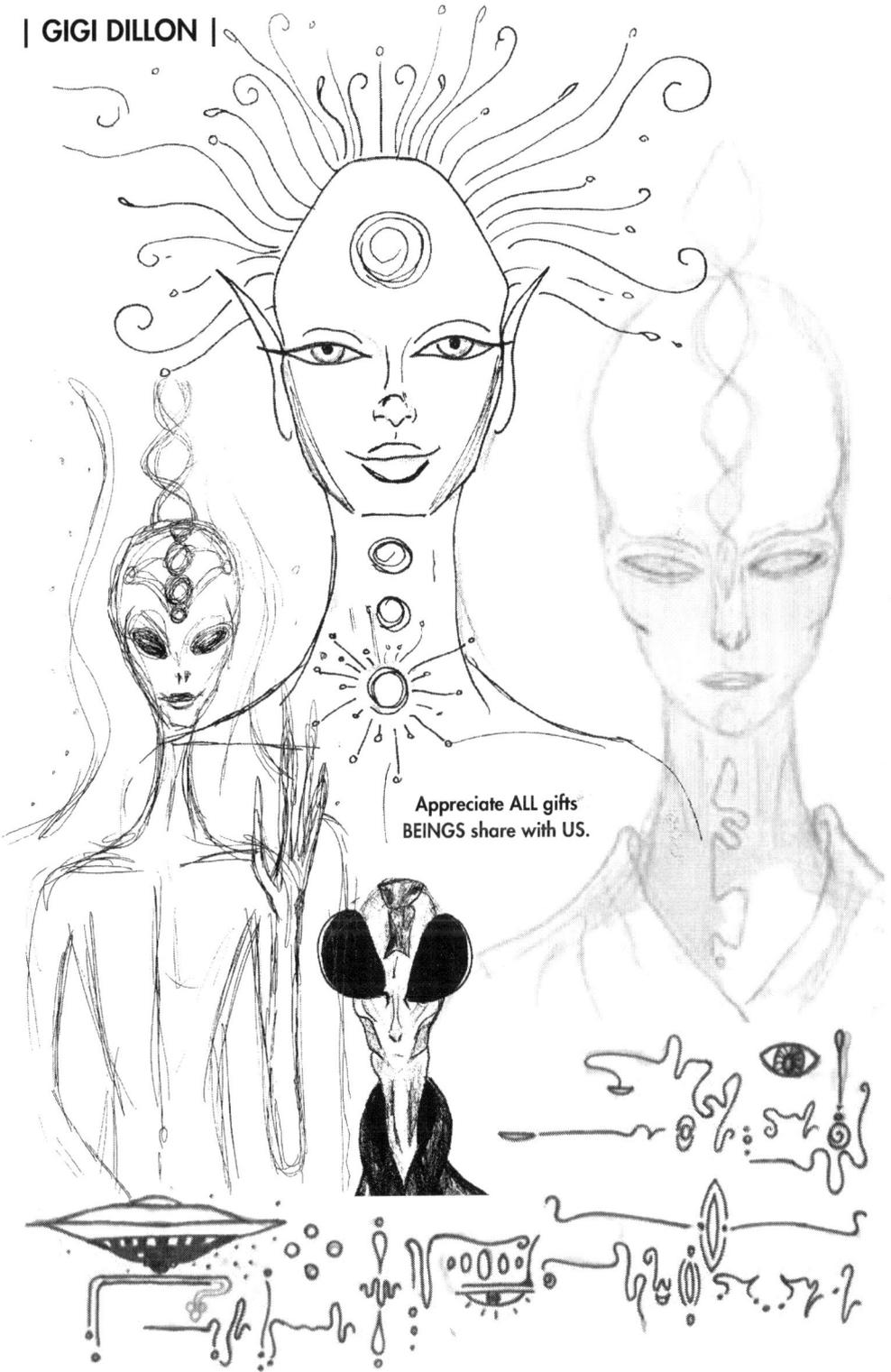

| GIGI DILLON |

Appreciate ALL gifts
BEINGS share with US.

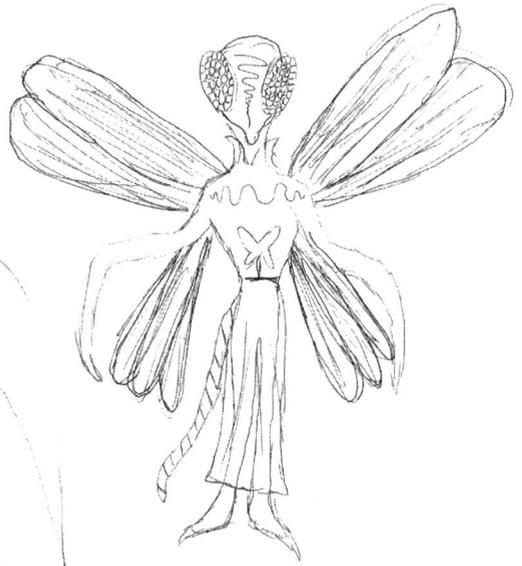

KOSMOS Konnection through
BEING, with BEINGS.

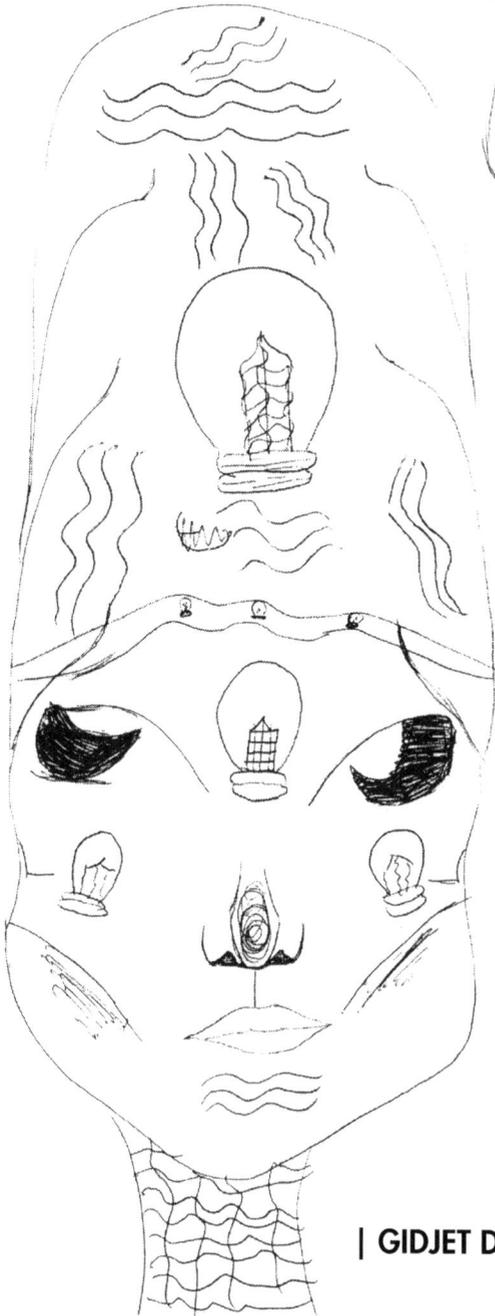

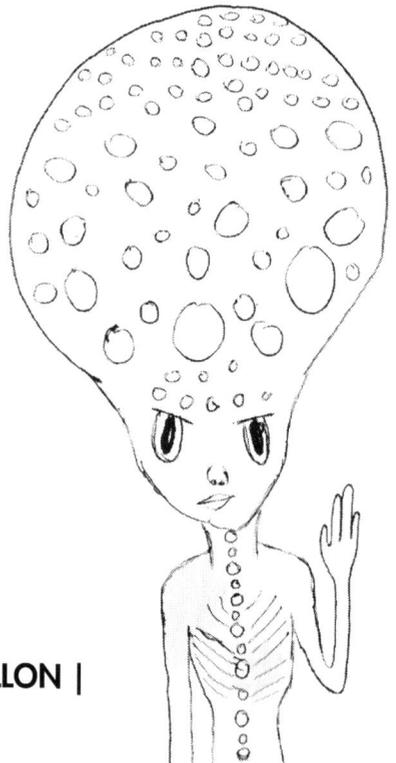

| GIDJET DILLON |

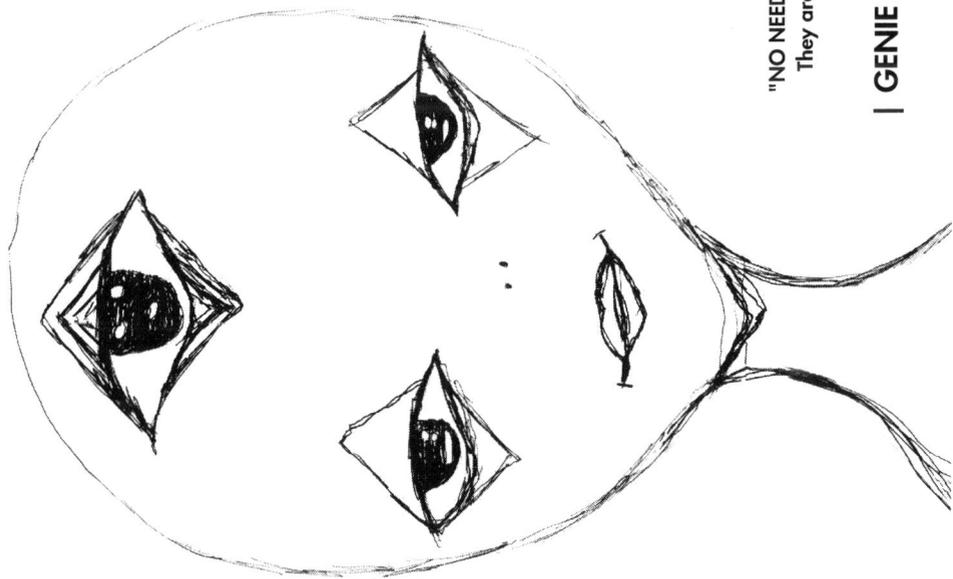

"NO NEED to be scared,
They are our friends.

| GENIE DILLON |

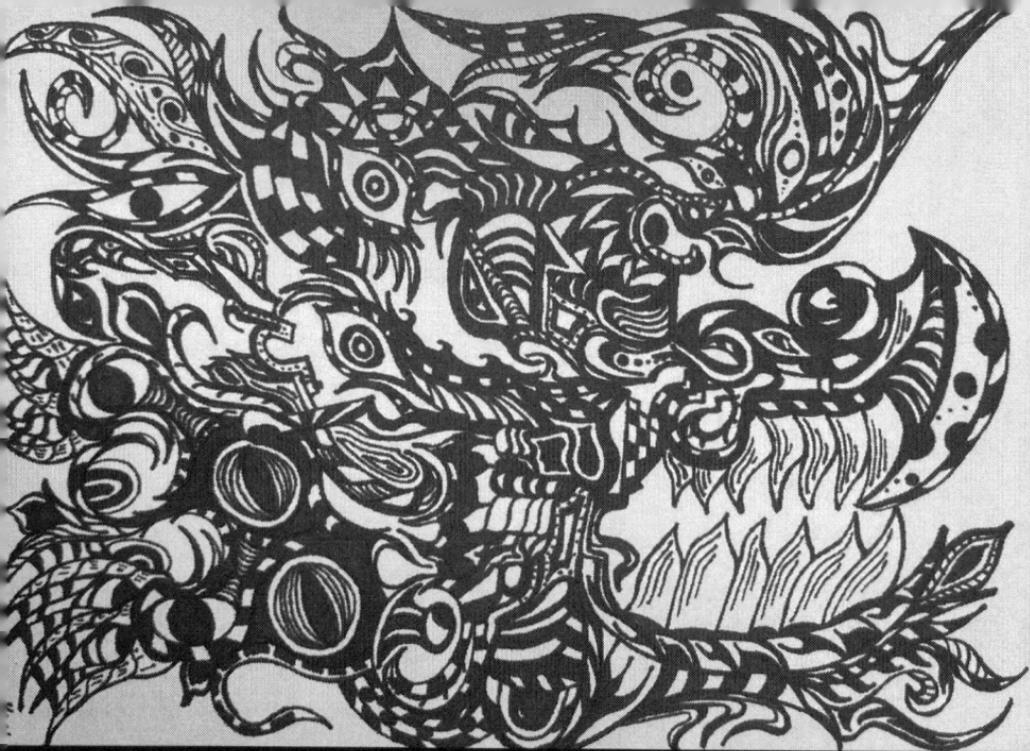

No matter what happens in your life, art will
always be there for you.

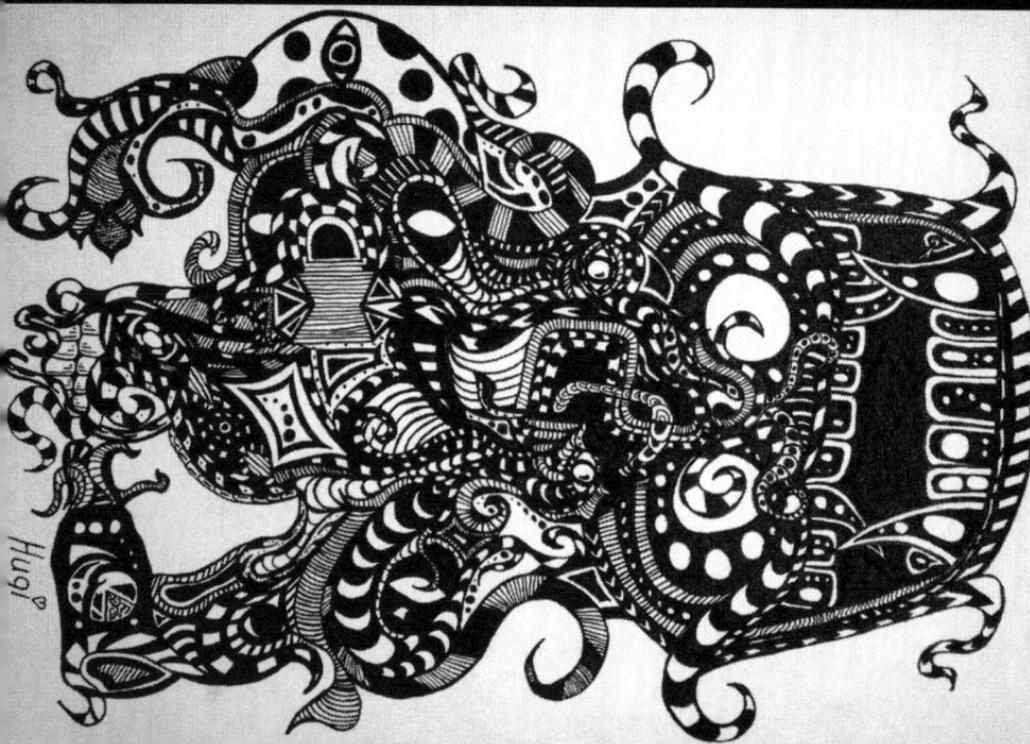

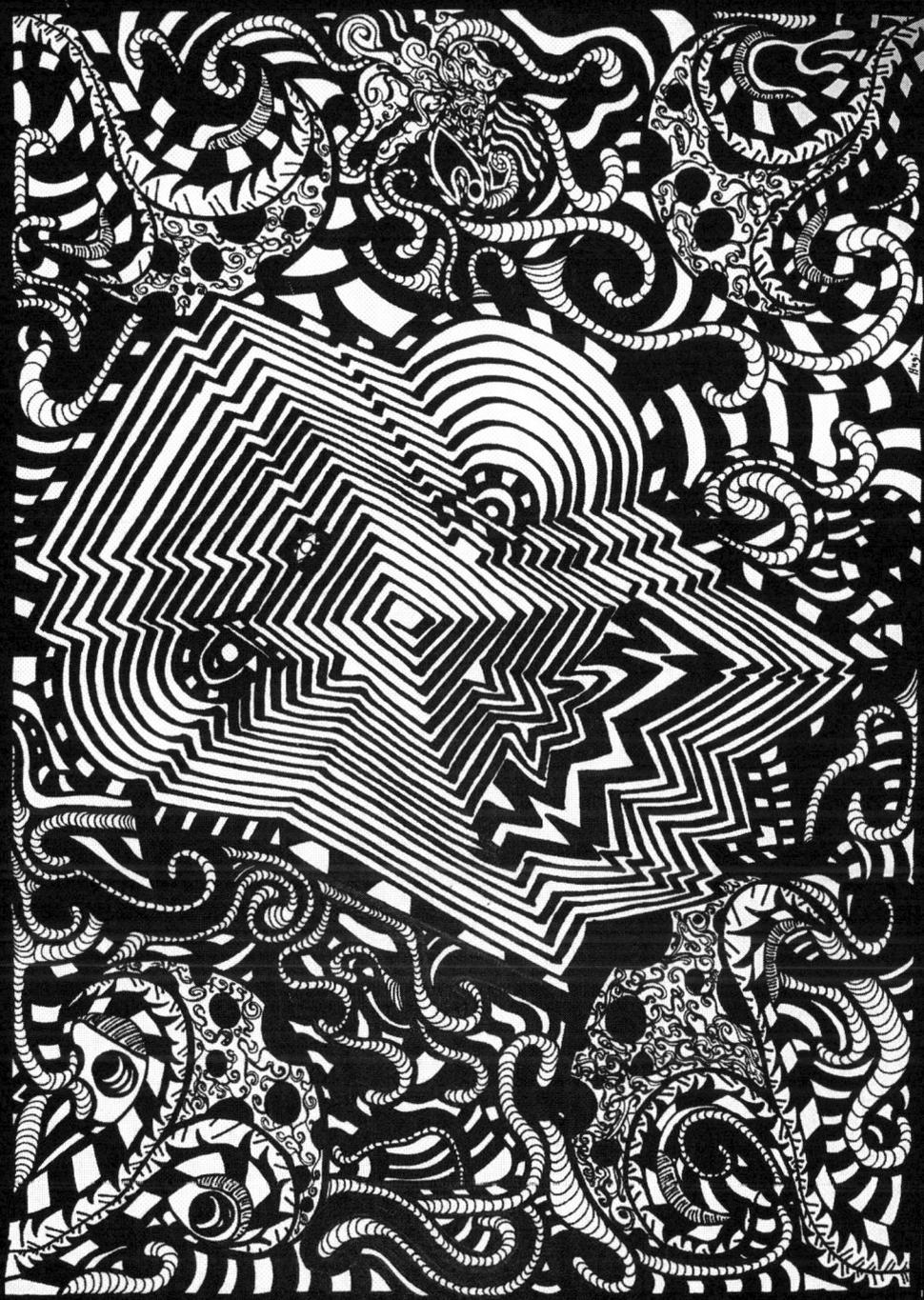

| HUGI |

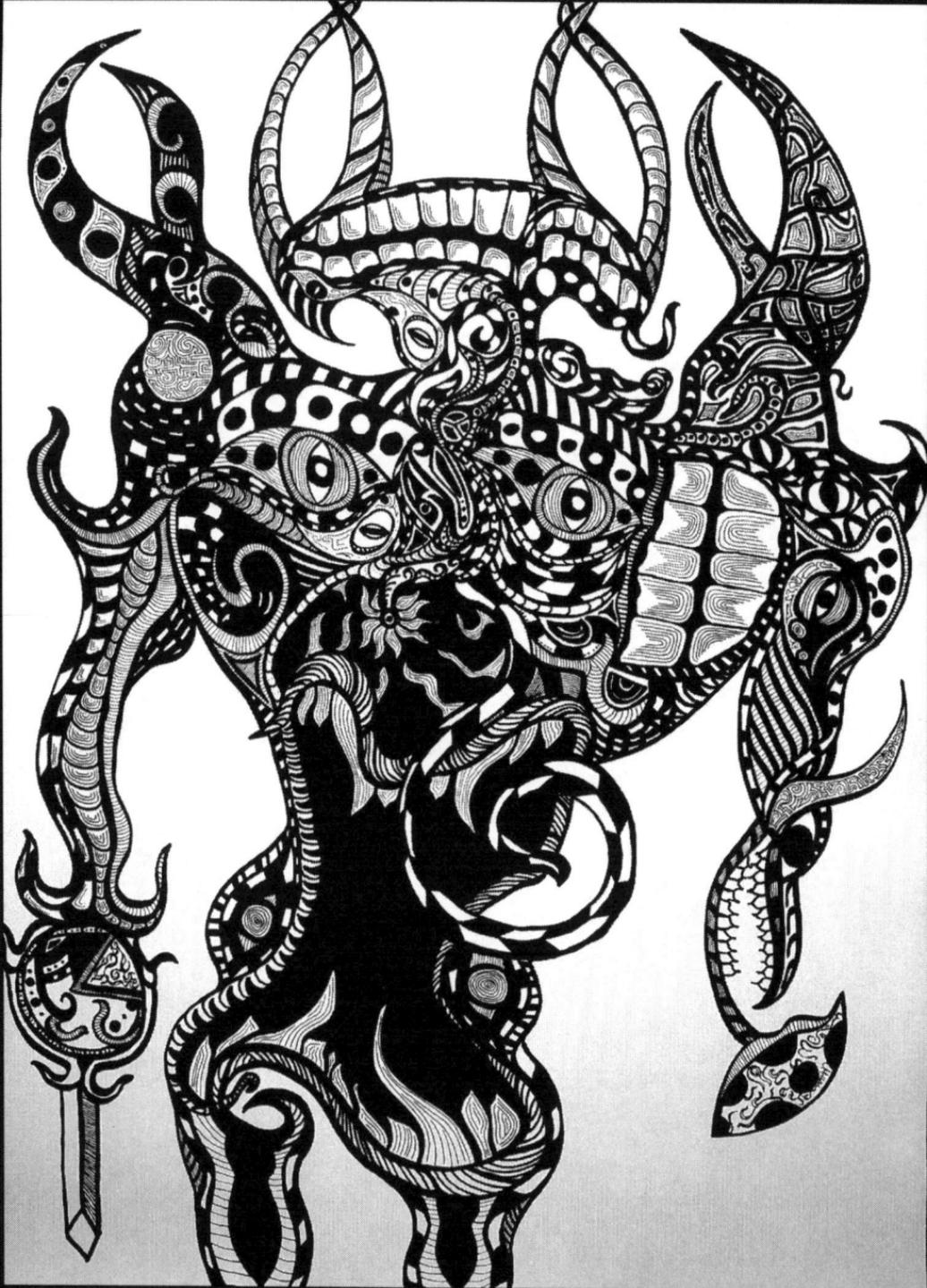

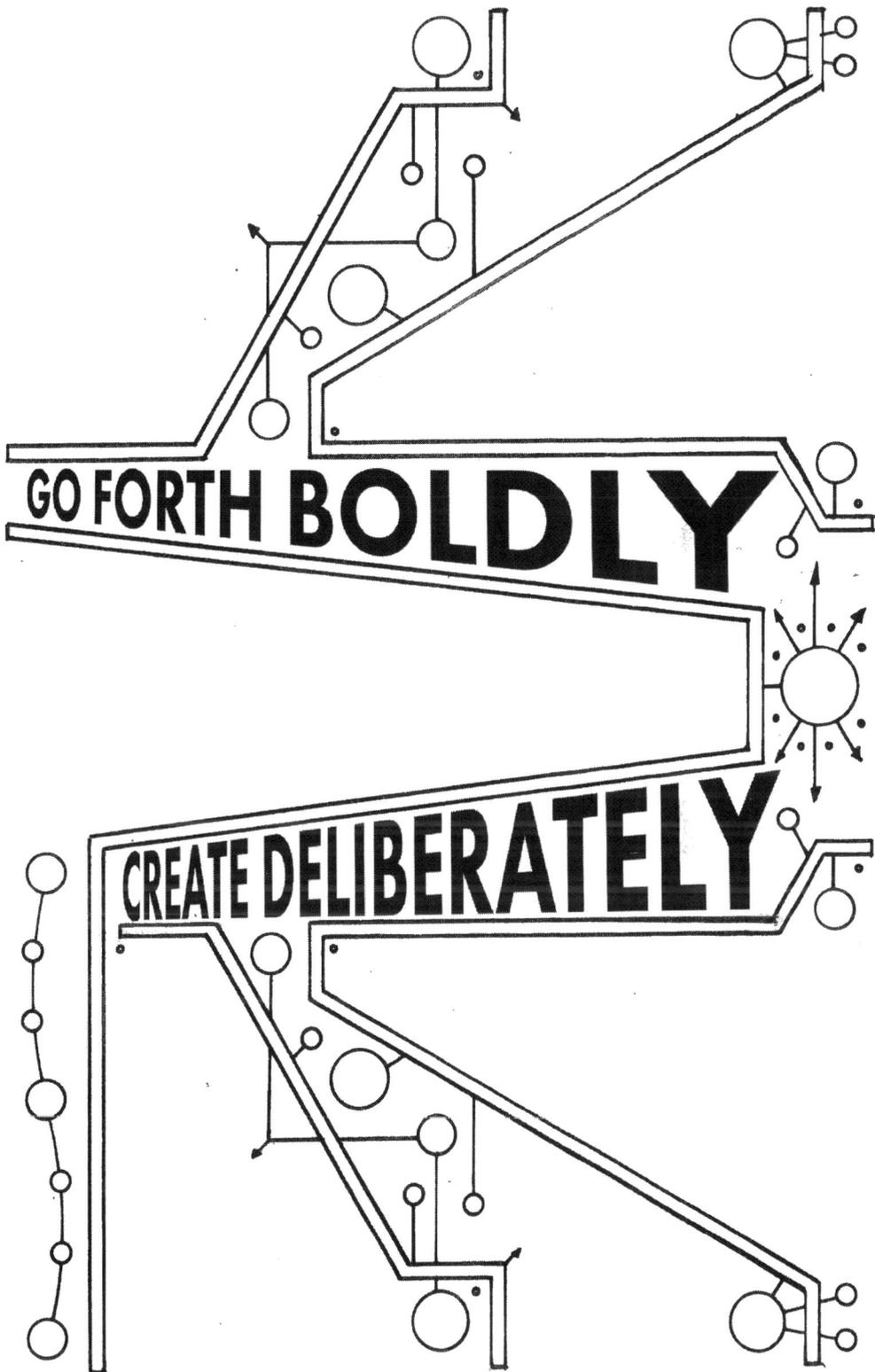

GO FORTH BOLDLY

CREATE DELIBERATELY

.

CREATE

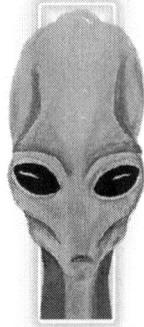

GRATITUDE GOES TO ALL OF THE ARTISTIC CONTRIBUTORS. THANK YOU FOR YOUR CONTRIBUTIONS TO THIS PROJECT! MAY YOU CONTINUE TO CREATE AND REMAIN EVER INSPIRED.

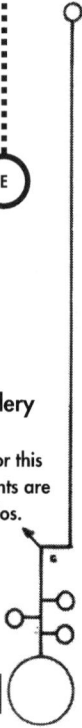

Made in the USA
Monee, IL
09 November 2023

46070103R00166